IN DEEPEST SYMPATHY

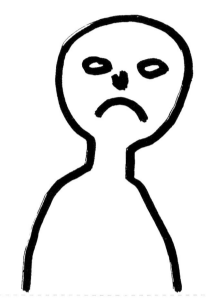

MESSAGE INSIDE CARD READS;
PULL YOURSELF TOGETHER

FOLD

SORRY I PAINTED THE WORD 'TWAT' ON YOUR GARAGE DOOR

PAINT THE WORD 'TWAT' ON SOMEBODY'S GARAGE DOOR AND THEN PUT THIS CARD THROUGH THEIR LETTER-BOX.

QUIZ

Q. WHERE IS THE SACRAFICIAL LAMB?

PULL YOURSELF
TOGETHER

I COULDN'T

HELP IT

A. THE SACRAFICIAL
LAMB IS BEING
KEPT AS A PET
BY STUDENTS FROM
THE UNIVERSITY.

PUT THIS
SIGN UNDER
THE WINDSCREEN
-WIPER ON
SOMEBODY'S
CAR. →

WHO ARE YOU?

DO YOU EVER THINK ABOUT WHO YOU ARE? I BET YOU DON'T. ALL YOU EVER THINK ABOUT IS WORK AND GIRLS AND FOOTBALL AND WHAT YOU'RE GOING TO HAVE FOR YOUR DINNER. IF I ASKED YOU "WHO ARE YOU?", YOU'D PROBABLY SAY "I'M BOB WANKER". (OR WHATEVER YOUR SILLY NAME IS) WELL MR BOB WANKER I'VE GOT SOME SURPRIZING NEWS FOR YOU. YOU ARE NOT BOB WANKER, SON OF GEORGE AND MILDRED WANKER. YOU ARE IN FACT 457 CREATED BY ME, DR. X. IN MY LABORATORY. THE EXPERIMENT THE RESULT OF EXPERIMENT N⁰ IN QUESTION INVOLVED COMBINING MOUSE SHIT AND RAT SHIT AND MIXING IT WITH A BEATEN EGG. THIS MIXTURE WAS PUT IN THE OVEN FOR AN HOUR AND THUS YOU WERE BORN.

THIS IS TRUE
YOU CAN TELL OTHERS

THIS IS A
SIGN FOR
YOU IF YOU
ARE A
SHOPKEEPER

CLOSED

PLEASE COME BACK DURING BUSINESS HOURS AND WE WILL ATTEMPT TO SELL YOU THINGS

WHY ARE YOU HERE?

WHY ARE YOU STILL HERE? I TELL YOU TO DISAPPEAR? I DIDN'T DISTINCTLY REMEMBER TELLING YOU TO DISAPPEAR. I'M WATCHING YOU READ THIS AND IF YOU DON'T DISAPPEAR RIGHT NOW I'M GOING TO LEAP OUT AT YOU AND BASH YOUR THICK HEAD WITH A CRICKET BAT AND THEN YOU'LL DISAPPEAR IN AN AMBULANCE THE CHOICE IS YOURS.

WHEN YOU ARE PLACING THIS SIGN BE CAREFUL NOT TO PULL TOO HARD AT THE WINDSCREEN WIPER - THEY ARE EASILY BROKEN. THINK OF IT LIKE THE WING OF AN INJURED BIRD. DON'T YANK AT IT BECAUSE IT'S REALLY DELICATE.

GO AWAY WE'RE

CLOSED

WE SHOULD BE OPEN BUT WE'RE NOT

WHY NOT SPEND SOME TIME IN THE 'WATER TANK'™ ?

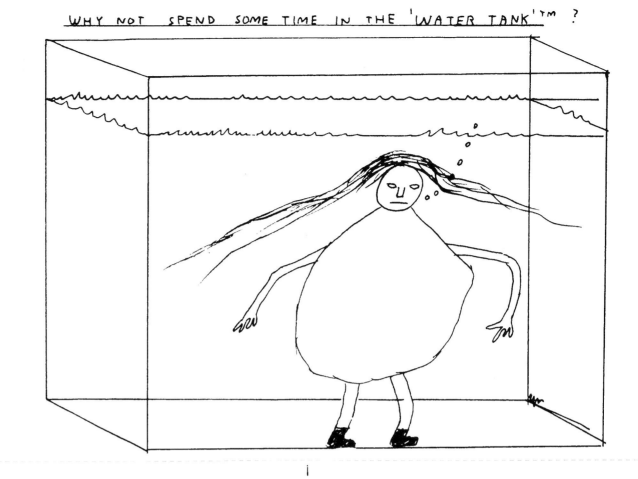

QUIZ

Q. WHAT IS THE ~~████~~ MONKEY EATING?

Q. WHAT IS THE WHALE EATING ?

Q. WHAT IS THE FIREMAN EATING ?

Q. WHAT IS THE STRANGE MAN IN THE BACK GARDEN EATING ?

Q. WHAT IS MONGO EATING ?

FOLD

HAPPY BIRTHDAY DEAR FRIEND

GOD BLESS YOU

EVER WONDERED WHAT IT'S LIKE TO BE IN A BIG TANK ▨ FULL OF WATER? ▬▬▬ ▬▬▬ ▬▬▬▬ ▬▬▬ ▬▬▬

FILL IN THE FORM.

TICK:

☐ YES! I WANT TO COME AND CLIMB IN THE 'WATER TANK'

☐ NO

☐ DON'T KNOW

☐ MR ☐ MRS ☐ MISS

NAME |||||||||||||||||||||
SURNAME |||||||||||||||||||||
ADDRESS |||||||||||||||||||||
POST CODE |||||||||||||||||||||
CITY |||||||||||||||||||||
PROFESSION |||||||||||||||||||||
TELEPHONE |||||||||||||||||||||

DO YOU HAVE YOUR OWN SWIMMING TRUNKS?
☐ YES ☐ NO
DO YOU WANT TO BORROW A PAIR?
☐ YES ☐ NO
HOW LONG CAN YOU HOLD YOUR BREATH?
☐ 1 MIN ☐ 1-3 MINS ☐ 3-10 MINS ☐ 10 MINS - 1 HOUR

ANSWERS

A. THE MONKEY IS EATING A HUGE YELLOW BANANA.

A. THE WHALE IS EATING A BEIGE VAUXHALL ASTRA SALOON 1.6 L (DIESEL) REGISTRATION PLATE: ARR 183G

A. THE FIREMAN IS EATING A FLAME-GRILLED WHOPPER.

A. THE STRANGE MAN IN THE BACK GARDEN IS EATING RUBBISH FROM THE BIN.

A. MONGO IS EATING AN ARM.

50p 50p 10p 10p 5p

FOLD (NEATLY)

IF YOU BOUGHT THIS CARD IN THE SHOPS THE RECOMMENDED RETAIL PRICE WOULD BE £1.25p

→

TEAR OUT THIS CARD
AND USE IT YOURSELF
OR ALTERNATIVELY
MAKE POOR-QUALITY
PHOTOCOPIES OF IT
AND SELL IT IN THE
STREET IN THE TOWN
FOR £2 EACH.
CALL IT A 'HANDY
ORGANISER' AND SAY
THEY COST £10 IN
THE SHOPS. IF YOU
SELL MORE THAN
460 IN A DAY
WRITE AND TELL ME
AND MAYBE WE
COULD ORGANISE SOME
SORT OF COMPETITION.
(460 IS MY RECORD)

AFFIX
STAMP
UPSIDE DOWN
(2ND CLASS)

HER MAJESTY THE QUEEN

BUCKINGHAM PALACE

LONDON W1

ENGLAND U.K.

DEAR YOUR MAJESTY,

I HAVE LONG BEEN A FAN OF YOURS AND LOVE THE WAY THAT YOU DRESS. IT'S SO REGAL. I PARTICULARLY LIKE YOUR CROWNS AND WAS WONDERING IF BY CHANCE YOU HAD ANY OLD ONES WHICH YOU DIDN'T WANT ANYMORE WHICH YOU WOULD LIKE TO PASS ON TO ME. AT THE MOMENT I HAVE TO MAKE DO WITH ONES I MAKE MYSELF. IF YOU DON'T HAVE ANY CROWNS - NO PROBLEM - HOW ABOUT ONE OF THOSE BIG BEJEWELLED STICKS WITH THE ROUND THING ON THE END? OR EVEN ONE OF THOSE FANCY COAT-THINGS WITH THE FURRY COLLAR? I COULD ALSO USE AN OLD THRONE IF YOU HAVE ONE BECAUSE WE DON'T HAVE ANY-THING TO SIT ON AT OUR HOUSE AND I'VE GOT A MANKY ANKLE - I'VE GOT A VAN SO I COULD COLLECT IT. IF YOU DON'T HAVE ANY OF THIS STUFF IT'S OK. - JUST GIVE US A OLD DRESS AND A HAT - WE'RE DOING THE DECORATING AT HOME JUST NOW AND I NEED SOMETHING TO THROW ON OVER MY NEW OVERALLS SO I DON'T GET PAINT ON THEM. JUST LEAVE THEM IN A POLYTHENE BAG BY THE PALACE GATES IF YOU LIKE. IF YOU CAN'T LET ME HAVE ANYTHING. DON'T WORRY, I WILL NOT TAKE POT-SHOTS AT YOU FROM A TALL BUILDING WITH MY HIGH-POWERED RIFLE (I AM A GIFTED MARKSMAN). HOPE YOU ARE WELL,

MUCH LOVE,
YOUR LOYAL SUBJECT,

XXXX

AFFIX PASSPORT-SIZED PHOTO OF YOURSELF WEARING HOMEMADE CROWN.
WRITE YOUR NAME AND ADDRESS CLEARLY IN THE SPACE BELOW - REMEMBER TO INCLUDE A DAYTIME TELEPHONE NUMBER.

DAVID SHRIGLEY

WHY WE GOT THE SACK FROM THE MUSEUM

REDSTONE PRESS

First published 1998, reprinted 2013
by Redstone Press
7a St Lawrence Terrace, London W10 5SU
www.theredstoneshop.com

Design: Julian Rothenstein Artwork: Otis Marchbank
Production: Tim Chester
Manufactured by C & C Offset Printing Co. Ltd.

ISBN 978 1870003 77 3

A catalogue record for this book is available from the British Library

TIME TO CHOOSE

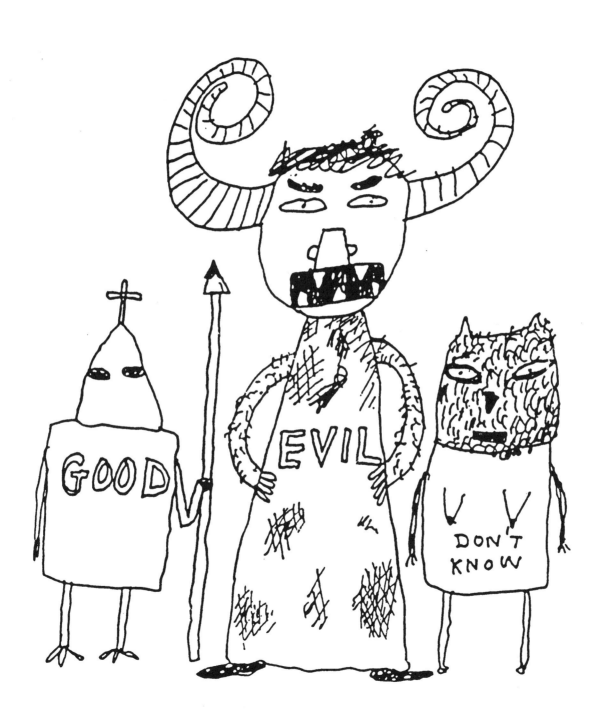

INTRODUCT

The most fundamental – and the most difficult – task for the creative artist is to get the audience to suspend disbelief. David Shrigley doesn't even try to do this; rather his works are enactment of the ground of the impossibility of our own suspension of disbelief; and the Icarus-like trajectory which we describe when we try to elude its surly surfeit of gravity.

Shrigley is thus, paradoxically, an artist who achieves that rarest of phenomena: the capacity to make his audience view the world in his terms entirely. After looking at five of these drawings you begin to find the world vaguely 'Shrigleyesque' (relationships are reduced to their component banalities, bodies to less than the sum of their parts), after looking at twenty of them you begin to find the world frighteningly Shrigley-like (the crisis in literature becomes a crisis in orthography and spelling, the death of affect is a result of spindly and smudged genitals), and after looking at over a hundred there is no plane of reality other than that described by Shrigley: giant, cantankerous dogs roam the land refusing to let you use their deodorant sticks.

In Shrigley's world view the capacity for line to express anything is imperilled, on the one hand by naïve glossing and on the other by matt betrayal. The Shrigley world is post-lapsarian masquerading as pre-lapsarian: these are humorous drawings done by the child murderers of child murderers. It's no accident – I feel – that some of Shrigley's more sexual depictions bear an uncanny resemblance to the drawings Dennis Nilsen, the serial killer, did of his victims.

Shrigley is showing that all of artistic conception is, in a very important sense, *mis*-conception; and that the misconception is implicit in the alleged antinomies: naïve/sophisticated; whole/part; framed/unconstrained; to/scale; in/perspective; naturalism/fantasy. Shrigley works to disrupt these by upsetting the formal properties of his drawings, muddying borders, frames, and even the ontological basis of depiction itself.

To call Shrigley's drawing style any*thing* in particular would be a mistake. Despite the apparent objectifications they deal with, these are not, in fact, drawings of things at all; rather, they are drawings of the shapes that things, people, ideas and emotions make in our lives. I'm not even sure that it would be altogether accurate to call these works drawings at all.

J.G. Ballard once described the conceptual sculptor Damien Hirst as 'a novelist who writes very short books', but this wouldn't grasp what Shrigley is up to. Nor is he a cartoonist except in this particular sense: the very best of cartoonists achieve both a *reductio ad absurdem* – ideas and captions internally undermining one another; and a *reductio ad infinitem* – captions and ideas reflect each other in an endless hall of reflexivity. Their cartoons, on this analysis, become closer to ideogrammatic forms of written language, such as Chinese characters. I think this perhaps captures Shrigley's work to some extent. Indeed in some bizarre future one could imagine a vast keyboard and on each key a Shrigley image, all ready for one to type out Shrigleyish.

There's that, and there's the fact that this artist takes on everything: memory and forgetting, love and hate, murder and preservation, god and godlessness. Shrigley's quality of line is such as to – in and of itself – imply the universal in the particular and its awful reversal.

I'm convinced that he is a very great nam. Even though I have no idea what a nam is.

WILL SELF, *London 1998*

CONTENTS

FROM MY DAYS DRAWING IN THE COURTROOM

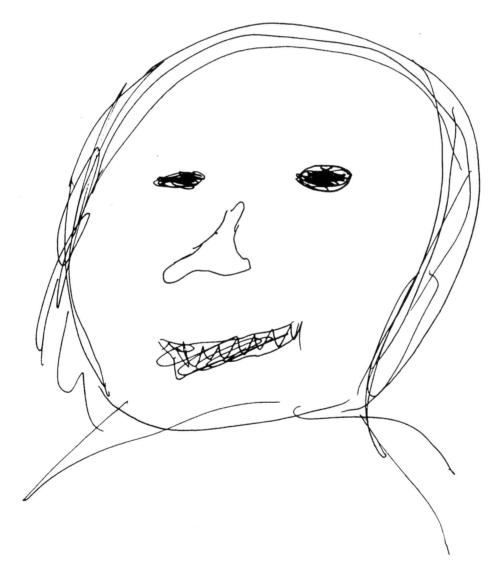

THE ACCUSED

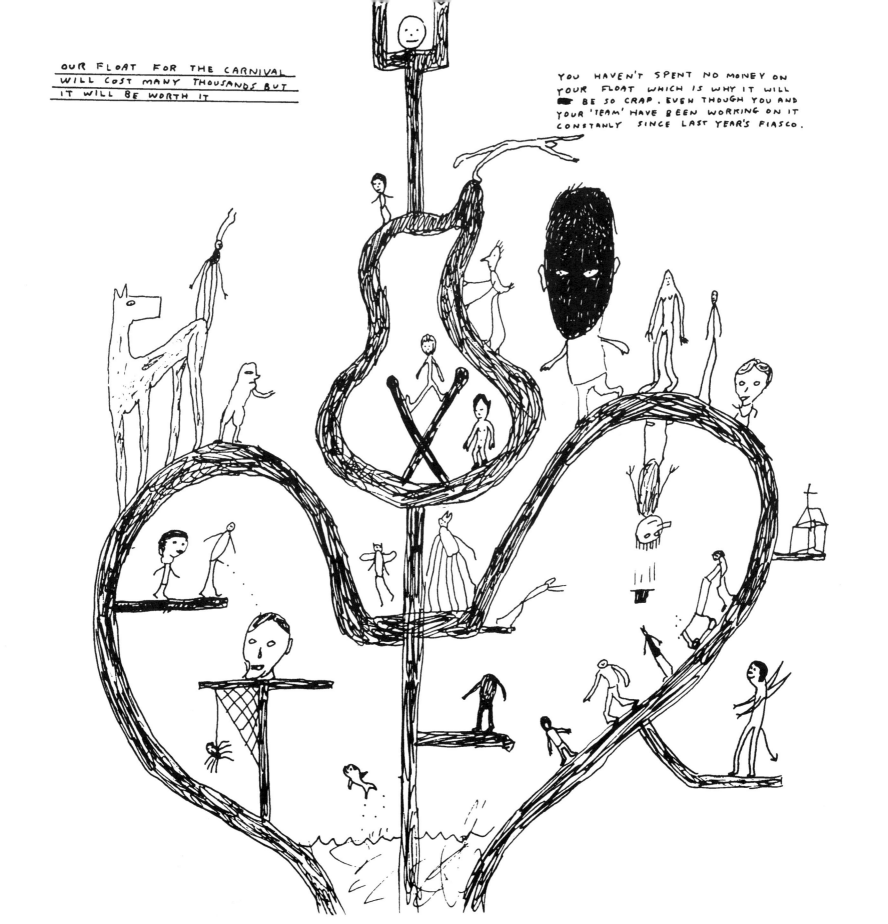

OUR FLOAT FOR THE CARNIVAL
WILL COST MANY THOUSANDS BUT
IT WILL BE WORTH IT

YOU HAVEN'T SPENT NO MONEY ON
YOUR FLOAT WHICH IS WHY IT WILL
BE SO CRAP. EVEN THOUGH YOU AND
YOUR 'TEAM' HAVE BEEN WORKING ON IT
CONSTANLY SINCE LAST YEAR'S FIASCO.

THE PROBLEM

THE ICON CARVER HAS A HANGOVER. THIS MORNING HE
HAS CARVED THE BLESSED VIRGIN BUT HAS DONE IT REALLY BADLY,
SO BAD IT'S AN INSULT TO GOD. HE FEELS THAT HE CANNOT BURN THE
PIECE AS THIS WOULD BE A WORSE INSULT (AND WOULD SURELY
ASSURE HIS PLACE IN HELL) - SO HE RESOLVES A SOLUTION -
HE WILL CUT THE TOP PIECE OF THE VIRGIN OFF AND ATTATCH IT AS
THE LOWER HALF OF ONE OF THE WISE MEN (THIS PIECE WILL
BE CARVED LATER WHEN HE HAS GOT OVER 'THE SHAKES') - HE IS
STILL NOT COMPLETELY AT EASE WITH THIS SOLUTION
AND AT LUNCHTIME HE WILL PRAY FOR FORGIVENESS.

(PLEASE) HELP ME WITH MY ACCOUNTS

SOMETIMES I THINK ABOUT ~~THINGS~~ (IN MY HEAD) AND IT'S ALL MIXED-UP
AND THEN I TRY AND WRITE IT DOWN IN ORDER TO SORT IT OUT
BUT IT'S STILL MIXED UP SO I TRY AND DRAW STRAIGHT LINES
AROUND IT TO SORT IT OUT BUT DOESN'T DO ANY GOOD

WHEN YOU PUT A SHELL TO YOUR EAR YOU CAN HEAR	NOTHING
WHEN YOU PUT A RADIO THAT DOESN'T WORK TO YOUR EAR YOU CAN HEAR	THE SEA
WHEN YOU PUT DIGITAL ALARM CLOCK RADIO TO YOUR EAR YOU CAN HEAR	SWISH, SWISH
WHEN YOU PUT THE BASS AMP TO YOUR EAR YOU CAN HEAR	BETTER
WHEN YOU PUT DOLLY'S TIT TO YOUR EAR YOU CAN HEAR	BASS RUMBLE
WHEN YOU PUT DOG'S WAGGING TAIL TO YOUR EAR YOU CAN HEAR	SOUND OF IT GOING IN
WHEN YOU PUT HEARING AID TO YOUR EAR YOU CAN HEAR	IT THINKING
WHEN YOU PUT EMPTY GLASS ON WALL TO YOUR EAR YOU CAN HEAR	SOUND OF WORMS
WHEN YOU PUT YOUR FINGER IN YOUR EAR YOU CAN HEAR	DEVELOPING SOUNDS
WHEN DOLLY PUTS HER TONGUE IN YOUR EAR YOU CAN HEAR	SQUIRRELS
WHEN YOU PUT OLLY DROPS IN YOUR EAR YOU CAN HEAR	SQUIRRELS
WHEN YOU PUT AEROSOL CAN TO YOUR EAR YOU CAN HEAR	NEXT DOOR
WHEN YOU PUT YOUR EAR TO TREE WHERE SQUIRRELS LIVE YOU CAN HEAR	SOMETHING
WHEN YOU PUT CIGARETTE TO YOUR EAR YOU CAN HEAR	RINGING
WHEN YOU PUT CAR TYRE TO YOUR EAR YOU CAN HEAR	NICE SOUNDS
WHEN YOU PUT TELEPHONE TO YOUR EAR YOU CAN HEAR	TIME
WHEN YOU PUT YOUR EAR TO FIRE ALARM YOU CAN HEAR	STRANGE NOISES
WHEN YOU PUT YOUR EAR TO THE RADIATOR YOU CAN HEAR	PEOPLE TALKING
WHEN YOU PUT YOUR EAR TO A ~~BUCKET~~ YOU CAN HEAR	PEOPLE TALKING
WHEN YOU PUT A PHOTOGRAPH TO YOUR EAR YOU CAN HEAR	SKIDS
WHEN YOU PUT A POTATO TO YOUR EAR YOU CAN HEAR	NUTS BEING EATEN
WHEN YOU PUT YOUR EAR TO THE BABY'S HEAD YOU CAN HEAR	SOUND OF SMOKE
SUB TOTAL	- - - - - - - - -
+ VAT 17.5%	- - - - - - - - -
TOTAL	- - - - - - - - -

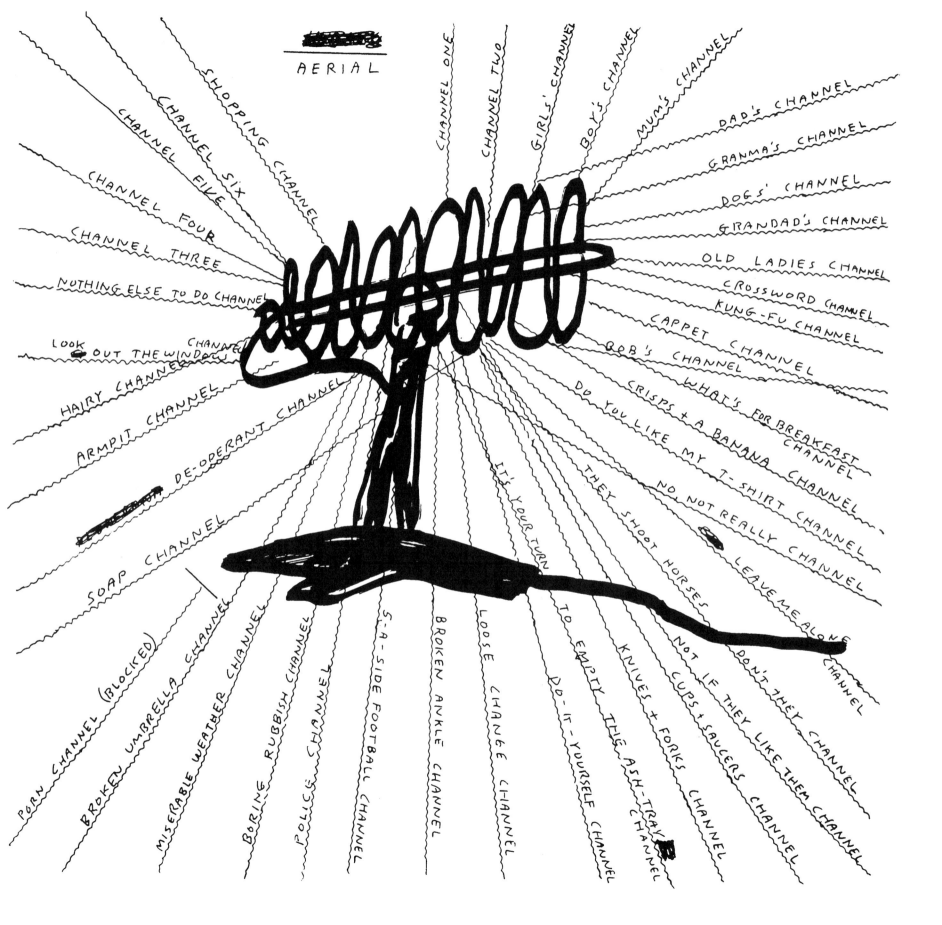

WHERE DO YOU KEEP YOUR NUTS ?

I KEEP MY NUTS IN THIS ~~----~~ HOLE IN THIS BIG TREE. IT AFFORDS THEM A CERTAIN AMOUNT OF SECURITY WHICH THEY WOULD NOT OTHERWISE HAVE IF I ~~----~~ KEPT THEM ON THE GROUND (AS IS THE CUSTOM WITH OTHER WOOLAND CREATURES) WHERE THEY WOULD BE PREY TO SQUIRRELS AND/OR BADGERS. I HAVE ALSO ADDED THIS 6 cm THICK STEEL DOOR TO DETER TREE-CLIMBING AND AIRBOURNE ~~----~~ THIEVES. INSIDE THE HOLE (OR 'VAULT' AS I PREFER TO CALL IT) THE NUTS ARE KEPT IN A LEAD CASKET WHICH IS PROTECTED BY A LAZER -BEAM ALARM SYSTEM CONNECTED TO THE POLICE STATION. IN ADDITION TO THIS EACH NUT HAS MY NAME AND ADDRESS WRITTEN ON IT IN INVISIBLE PEN WHICH SHOWS UP UNDER U.V. LIGHT.

MY NUTS ARE SAFE.

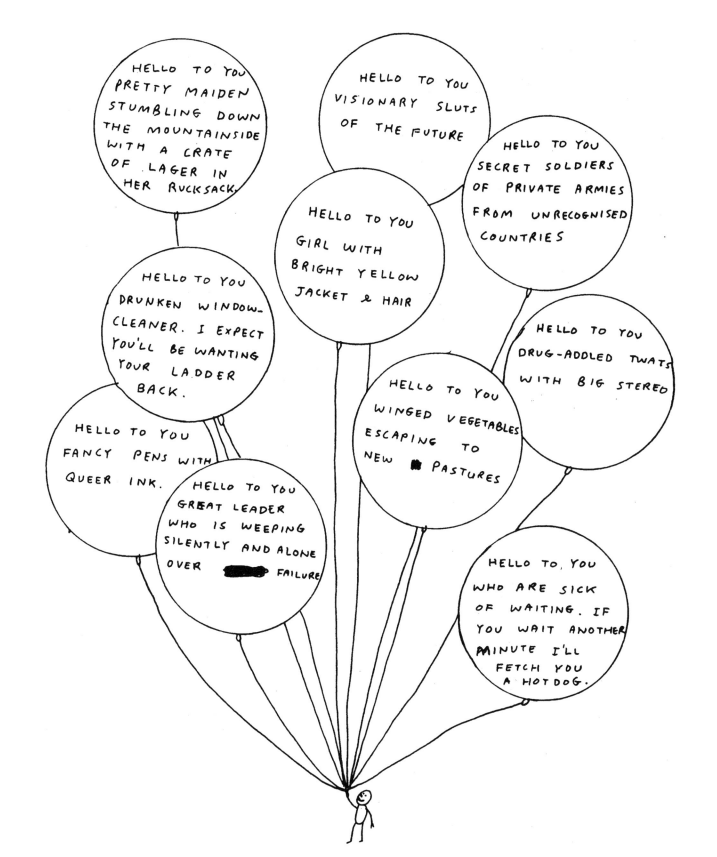

TYPES OF DREAMS

THE SURF DREAM EXPLAINED:

SURFER COULD REPRESENT:
~~YOU~~ YOU, YOUR FATHER, YOUR MOTHER, GIRLFRIEND, WIFE, DOG, LIFE, CAREER, CHILDREN, CAR, HEALTH, INVESTMENTS, MENTAL STATE, OR COULD REPRESENT NOTHING AT ALL, COULD JUST BE YOUR BRAIN MESSING YOU ABOUT WHILE YOU'RE ASLEEP.

WAVE COULD REPRESENT:
YOU, YOUR FATHER, YOUR MOTHER, GIRLFRIEND, WIFE, DOG, LIFE, CAREER, CHILDREN, CAR, HEALTH, INVESTMENTS, MENTAL STATE, OR COULD REPRESENT NOTHING AT ALL, COULD JUST BE YOUR BRAIN MESSING YOU ABOUT WHILE YOU'RE ASLEEP.

SURFBOARD COULD REPRESENT:
YOU, YOUR FATHER, YOUR MOTHER, GIRLFRIEND, WIFE, DOG, LIFE, CAREER, CHILDREN, CAR, HEALTH, INVESTMENTS, MENTAL STATE, OR COULD REPRESENT NOTHING AT ALL, COULD JUST BE YOUR BRAIN MESSING YOU ABOUT WHILE YOU'RE ASLEEP.

SHARKS COULD REPRESENT:
YOU, YOUR FATHER, YOUR MOTHER, GIRLFRIEND, WIFE, DOG, LIFE, CAREER, CHILDREN, CAR, HEALTH, INVESTMENTS, MENTAL STATE, OR COULD REPRESENT NOTHING AT ALL, ETC.

WHAT GOD WANTS

GOD WANTS SPIRITUAL FRUITS NOT RELIGIOUS NUTS

GOD WANTS MANKIND TO LIVE TOGETHER WITHOUT ARGUING

GOD WANTS WICKEDNESS TO BE STAMPED OUT

GOD WANTS US ALL TO GO TO CHURCH ON SUNDAYS

GOD WANTS US TO CALL OUR PARENTS EVERY WEEKEND

GOD WANTS US TO FEED OUR GUINEA PIGS AND WATER OUR BONSAI TREE

GOD WANTS US ALL TO BECOME VEGANS

GOD WANTS US TO STOP STEALING AND FIGHTING AND MURDERING

GOD WANTS US TO DRIVE CAREFULLY AND CALMLY

GOD WANTS US TO LOOK AFTER OUR KIDS AND READ TO THEM AT NIGHT

GOD WANTS THE COUNCIL TO FIX THE ROADS

GOD WANTS US TO RECYCLE OUR RUBBISH

GOD WANTS US TO SPONSOR A CHILD IN THE THIRD WORLD

GOD WANTS US TO LEARN FRENCH

GOD WANTS US TO LEARN MANNERS AND HUMILITY

GOD WANTS US TO STOP SMOKING IN PUBLIC PLACES

GOD WANTS THE CLEVER, SKILLFUL PEOPLE TO LOOK AFTER THE DIMWITS

GOD WANTS US TO USE ONLY SHARP TOOLS

GOD WOULD RATHER WE READ A BOOK THAN WATCHED DAYTIME T.V.

GOD WANTS US TO CLEAR UP AFTER OURSELVES

GOD WANTS US TO PLAY THE RECORD FROM BEGINNING TO END NOT JUST ONE TRACK

GOD DOES NOT WANT US TO GIVE HIM CLOTHES FOR HIS BIRTHDAY – THERE IS NO POINT IN DOING THAT – MANKIND HAS NO CLUE WHAT KIND OF CLOTHES GOD LIKES – UNLESS GOD SPECIFICALLY ASKS FOR A PARTICULAR GARMENT – THEN MANKIND SHOULD JUST GIVE GOD MONEY OR A GIFT VOUCHER.

I'M TRYING REALLY HARD, HONESTLY, BUT IT'S TOO
LATE AT NIGHT. SOMEHOW I JUST CAN'T SEEM TO
HIT THE NAIL ON THE HEAD. I'M IN SUCH A
RUDDY BAD MOOD, GRRRRR, RUBBISH, RUBBISH,
OH, ERRG, SUCH ABSOLUTE BLOODY NONSENSE. DAMN,
DAMN, ALL OF IT SEEMS SO POINTLESS AND PATHETIC,
I SUPPOSE I'LL JUST DRAW AROUND THINGS THAT
ARE LYING AROUND ON MY DESK AGAIN........

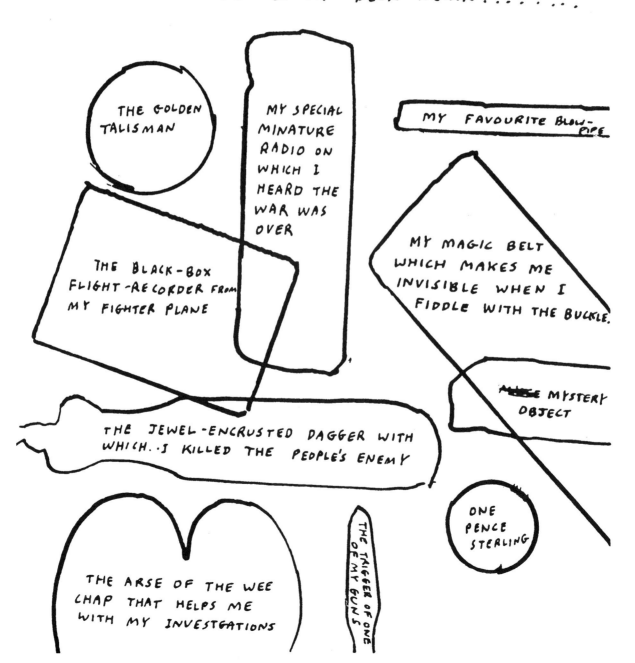

THE GOLDEN TALISMAN

MY SPECIAL MINATURE RADIO ON WHICH I HEARD THE WAR WAS OVER

MY FAVOURITE BLOW-PIPE

THE BLACK-BOX FLIGHT-RECORDER FROM MY FIGHTER PLANE

MY MAGIC BELT WHICH MAKES ME INVISIBLE WHEN I FIDDLE WITH THE BUCKLE.

MYSTERY OBJECT

THE JEWEL-ENCRUSTED DAGGER WITH WHICH..I KILLED THE PEOPLE'S ENEMY

ONE PENCE STERLING

THE ARSE OF THE WEE CHAP THAT HELPS ME WITH MY INVESTGATIONS

THE TRIGGER OF ONE OF MY GUNS

WIT WOM DO THEY BLAME THEY ?
WIT WHOM DOES THEY BLAME LIES?
WITH WHO DOES THE LIE?
WHO THEN IS TO LIE WITH THE BLAME?
WHOM WITH THE BLAME LIES ?
LIES WHOM AND THE BLAME DOES ?
WITH WHOM DOES THE BLAME ? LIES
WITH WHOM DOES THE BLAME LIE ?

WORKMAN VS. HIS TOOLS :

NONE OF THESE PENS WORK PROPERLY

(the phrase "NONE OF THESE PENS WORK PROPERLY" repeated many times in a cascading, diagonal arrangement, with variations such as:)

NONE OF THESE PENS WORK PROPERLY
NONE OF THIS PINS WORK PR
THESE PENS PIGS POORLY
FOR SHIT PENS
THE PETS WORK PROPERLY
NONE OF THESE PEN WORK PR
NONE OF THESE PI
NONE OF THESE PENS WORKP
NONE F THE P
N PROPERLY
N

DRAWING DONE WHILST IN
POLICE CUSTODY

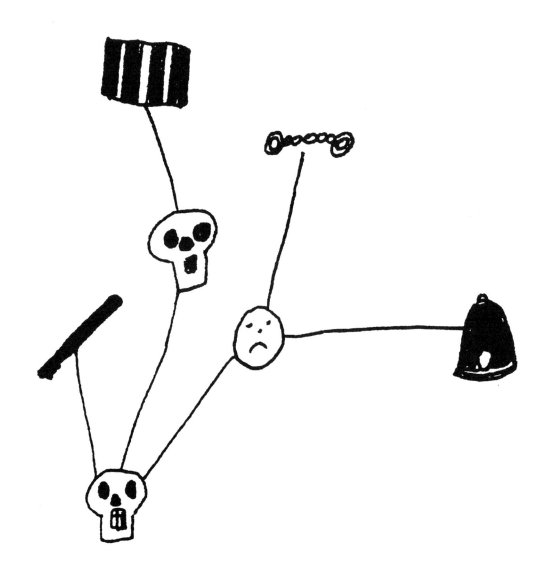

WE HAVE TO TALK ABOUT SOMETHING, WE HAVE ▪ TO START SOMEWHERE, SO LET'S MAKE THIS OUR STARTING POINT;

- -

SOME LOCATIONS (ALWAYS A GOOD PLACE TO START)

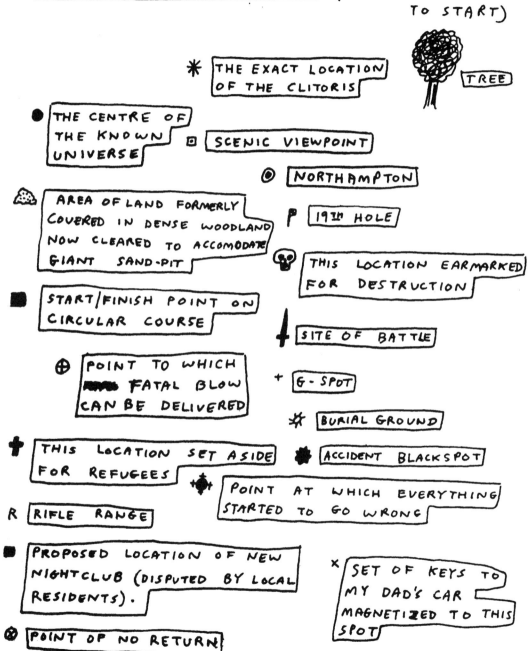

* THE EXACT LOCATION OF THE CLITORIS

TREE

● THE CENTRE OF THE KNOWN UNIVERSE

⊡ SCENIC VIEWPOINT

◎ NORTHAMPTON

△ AREA OF LAND FORMERLY COVERED IN DENSE WOODLAND NOW CLEARED TO ACCOMODATE GIANT SAND-PIT

P 19ᵗʰ HOLE

☠ THIS LOCATION EARMARKED FOR DESTRUCTION

■ START/FINISH POINT ON CIRCULAR COURSE

† SITE OF BATTLE

⊕ POINT TO WHICH FATAL BLOW CAN BE DELIVERED

+ G-SPOT

✳ BURIAL GROUND

✝ THIS LOCATION SET ASIDE FOR REFUGEES

✹ ACCIDENT BLACKSPOT

✠ POINT AT WHICH EVERYTHING STARTED TO GO WRONG

R RIFLE RANGE

■ PROPOSED LOCATION OF NEW NIGHTCLUB (DISPUTED BY LOCAL RESIDENTS).

x SET OF KEYS TO MY DAD'S CAR MAGNETIZED TO THIS SPOT

⊗ POINT OF NO RETURN

ALL MY PALS
ARE EVIL BASTARDS
EXCEPT YOU

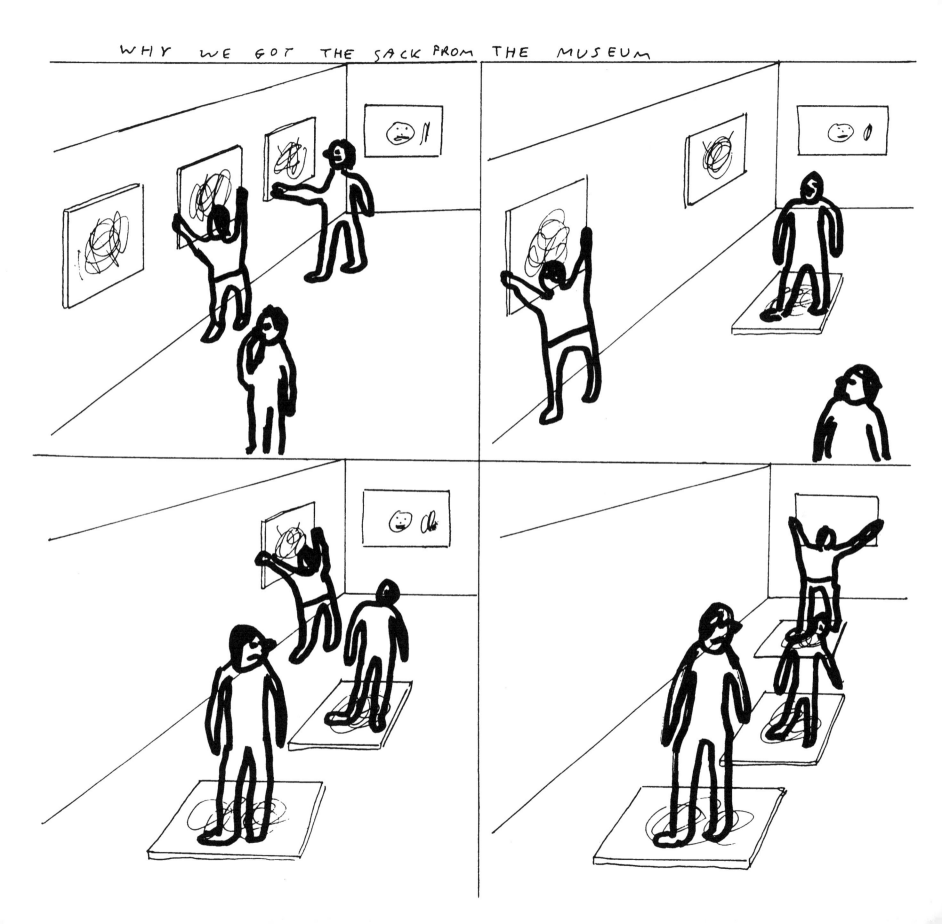

NEW SPACE

THIS IS THE SPACE THAT I HAVE BEEN ALOTTED. THOUGH VANDALS HAVE DEFACED IT SOMEWHAT, I STILL FEEL THAT I CAN MAKE SOMETHING OF IT WITH A BIT OF WORK. AFTERALL, I AM LUCKY TO HAVE A SPACE, SOME POOR BASTARDS DON'T HAVE ANY SPACE AT ALL.

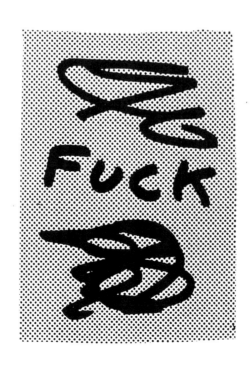

1. HEIRARCHY OF THINGS - SUBJECTIVE (TUESDAY)

WHISKEY

GIN VODKA RUM COLA WINE BEER

PEANUTS APPLES WATER TOAST CRISPS JELLY BABIES

SALT PEPPER SANDWICHES BICYCLE WHEELS SOUVENIR MUGS PORK PIE
ANDY MICHAEL KAREN WALTER JANICE POLICEMAN POLAR BEAR MUM GRAN CHEST OF DRAWERS

2. COMPLICATED LINKS BETWEEN THINGS

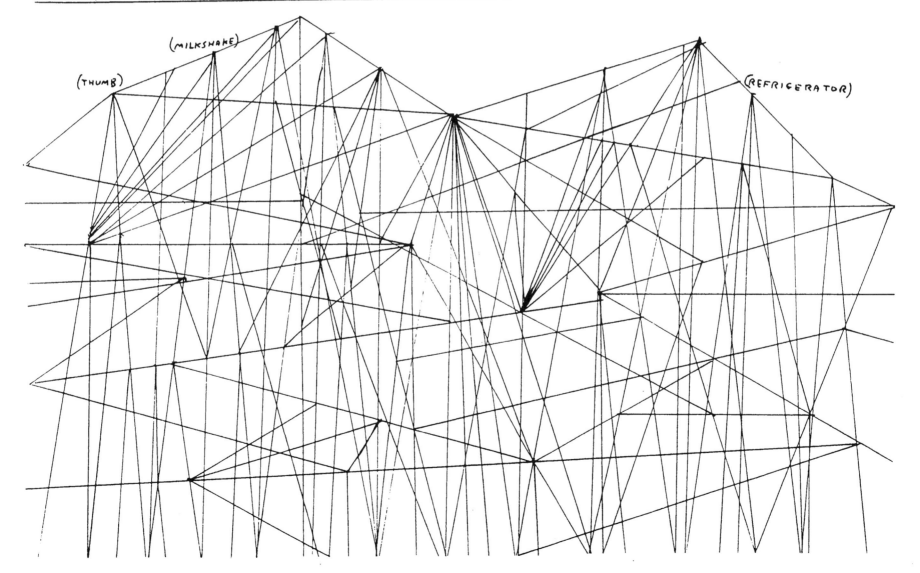

(MILKSHAKE)

(THUMB)

(REFRIGERATOR)

YOUR
PERFUME

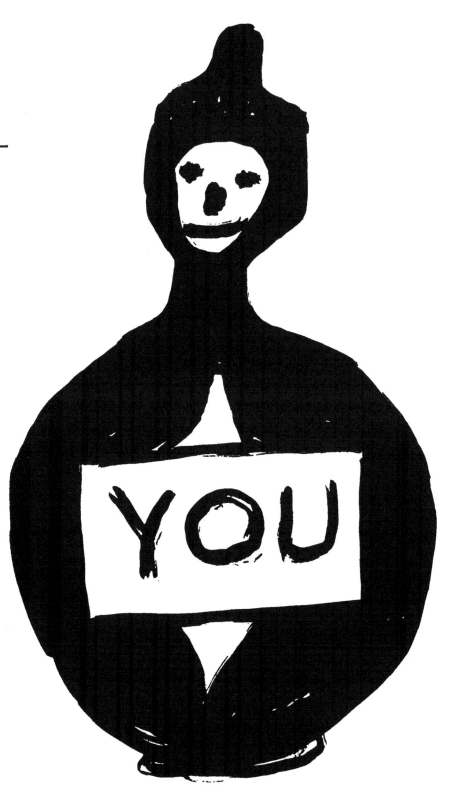

ALSO ~~AVAILABLE~~ AVAILABLE:

YOUR BODY SPRAY
YOUR DEODERANT
YOUR TALCUM POWDER
YOUR MOISTURIZER
YOUR SHAMPOO
YOUR CONDITIONER
YOUR HAIR GEL
YOUR SOAP
YOUR SHOWER GEL
YOUR TOOTHBRUSH
YOUR HAIRSPRAY
YOUR BUBBLEBATH
YOUR CLEANSING LOTION
YOUR BABY OIL

AND

THE SOLUTION THAT YOU
PUT YOUR CONTACT LENSES
IN AT NIGHT.

8

WITH THIS EIGHT I THEE WED. WITH
THIS EIGHT I PLEDGE ~~✦~~ MY UNDYING
LOVE FOR YOU. I WILL STAY WITH
YOU FOREVER AND LOOK AFTER YOU
WHEN YOU ARE ILL AND MOP UP
YOUR MESS. WITH THIS EIGHT I
WILL HONOUR AND CHERISH YOU WHATEVER.
THAT MEANS. SLIP YOUR FEET INTO
THE EIGHT THUS;

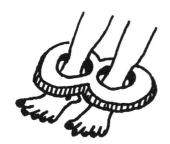

YOU WILL FIND IT DIFFICULT TO WALK
BUT THAT DOESN'T MATTER BECAUSE
I AM HERE TO LOOK AFTER YOU
MY DARLING.

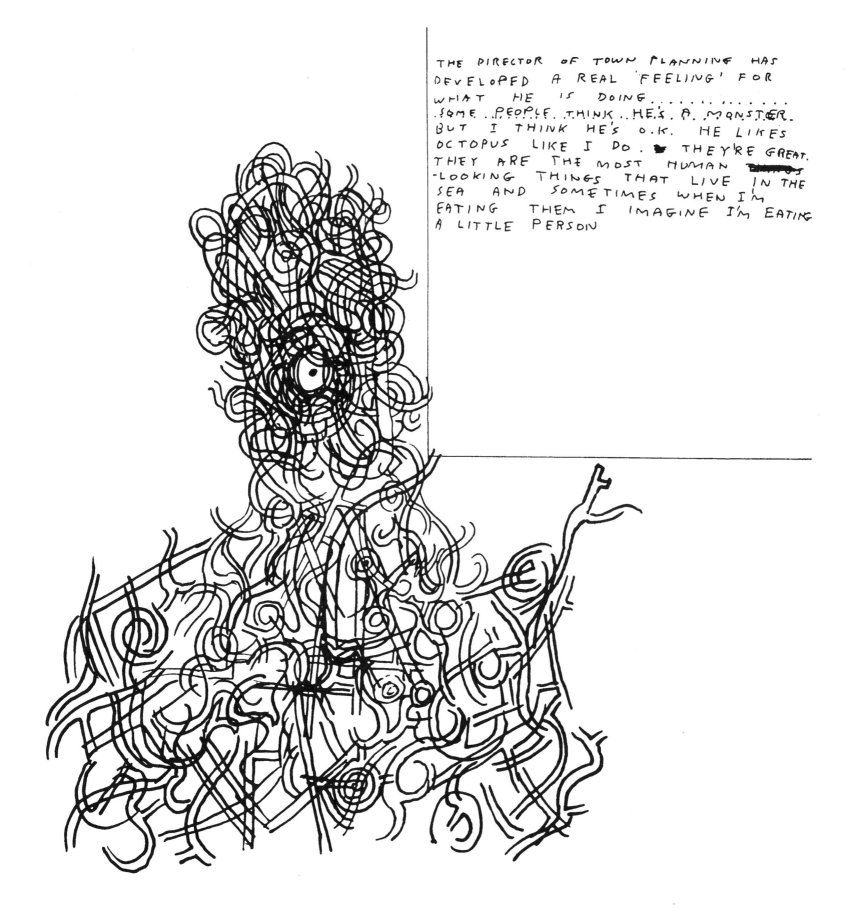

THE DIRECTOR OF TOWN PLANNING HAS
DEVELOPED A REAL 'FEELING' FOR
WHAT HE IS DOING............
.SOME .PEOPLE .THINK ..HE.S. A. MONSTER.
BUT I THINK HE'S O.K. HE LIKES
OCTOPUS LIKE I DO. ▸ THEY'RE GREAT.
THEY ARE THE MOST HUMAN ~~THINGS~~
-LOOKING THINGS THAT LIVE IN THE
SEA AND SOMETIMES WHEN I'M
EATING THEM I IMAGINE I'M EATING
A LITTLE PERSON

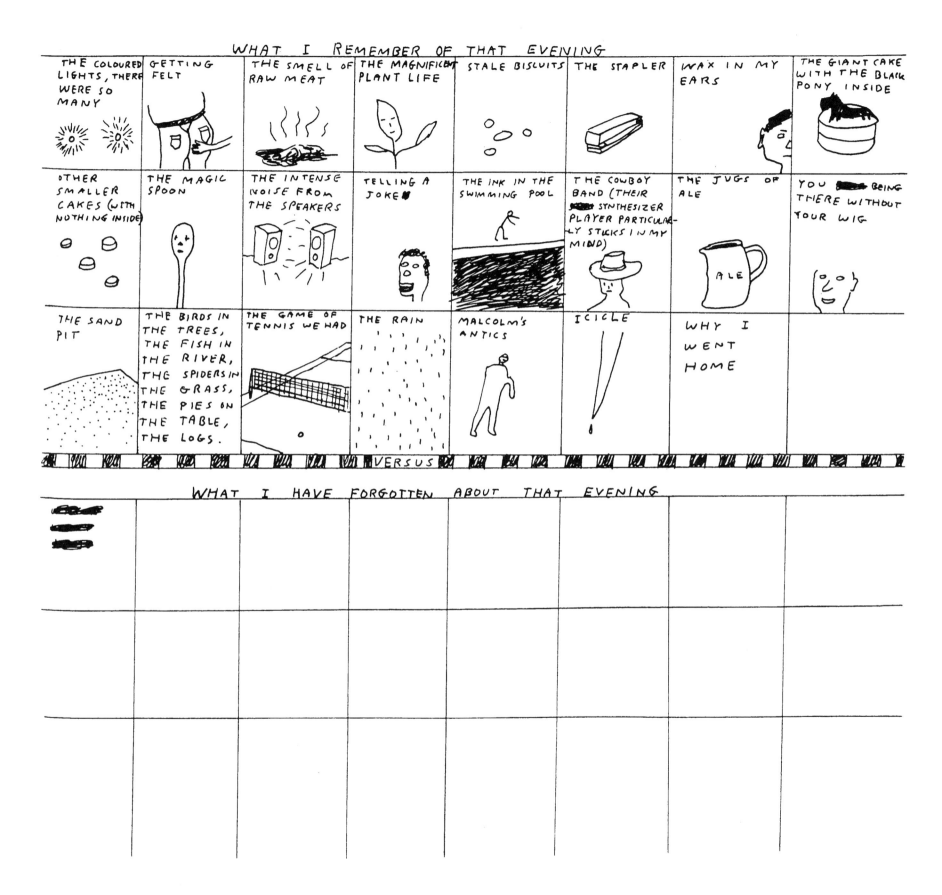

SPEAKING CLOCK LIES

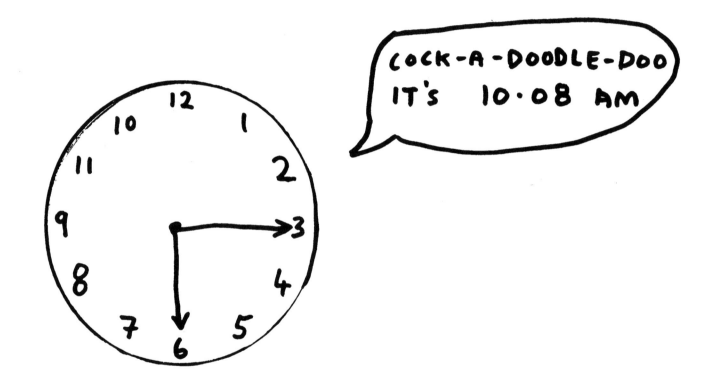

WE HERE ARE FLEXIBLE BECAUSE WE DO YOGA

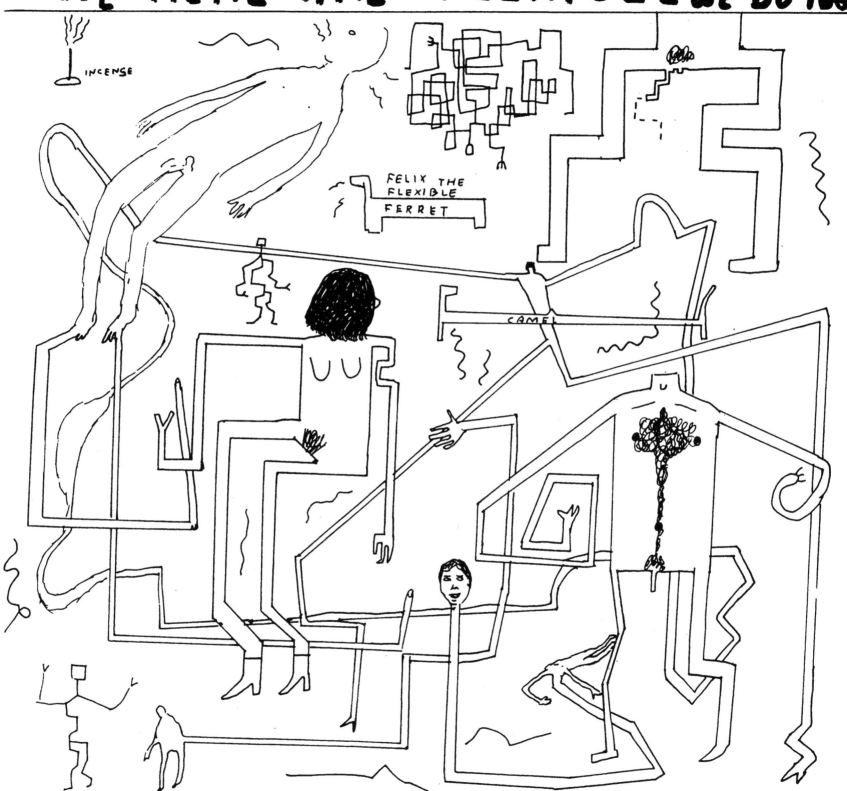

INCENSE

FELIX THE FLEXIBLE FERRET

CAMEL

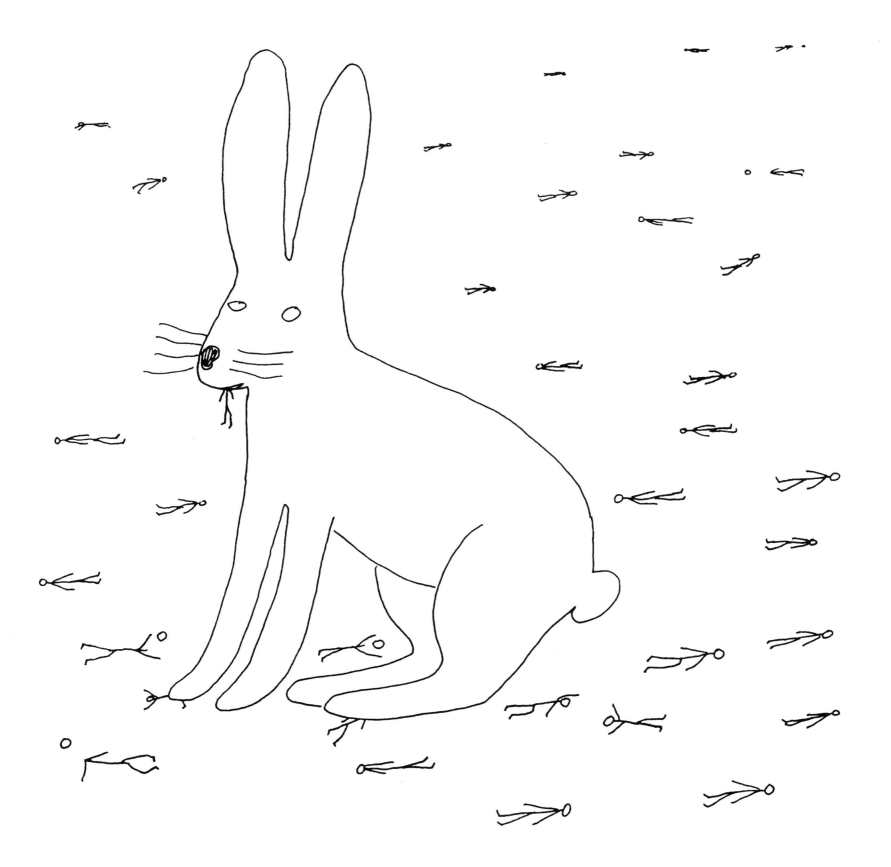

JOIN THE DOTS — IN YOUR HEAD
OR ON THE PAGE, IT DOESN'T MATTER

THE OCEANS BOUNTY

MERMAIDS ARE VERY EASY TO CATCH. THEY JUST SIT ON ROCKS SINGING WAITING FOR YOU TO HARPOON THEM. IT'S QUITE LEGAL TO KILL THEM SINCE THE AUTHORITIES (AND MOST OTHER PEOPLE) ARE UNAWARE OF THEIR ▬▬ EXISTANCE.

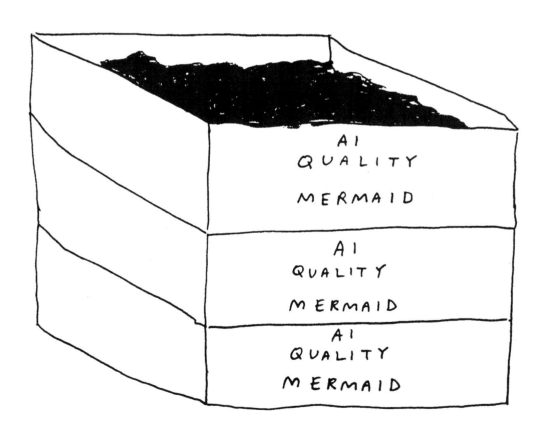

THE UNIT

IN THIS UNIT I RECEIVED YOUR
EXCELLENT TUTELAGE. I HOLD THIS
SPACE DEAR BECAUSE OF IT. THE
METAL ON THE FLOOR, THE DUST, THE
FOUL SMELL — I HOLD THESE THINGS
DEAR BECAUSE THEY SYMBOLIZE MY
ELIGHTENMENT INTO YOUR WISE AND
GRACEFUL WAYS. YOU ARE A
PROPHET AND A SAINT. YOU SAID
YOU WOULD MEET ME HERE AT
6 O'CLOCK AND YOU ARE NOW AN
HOUR AND A HALF LATE.

OFFERS OF LOVE

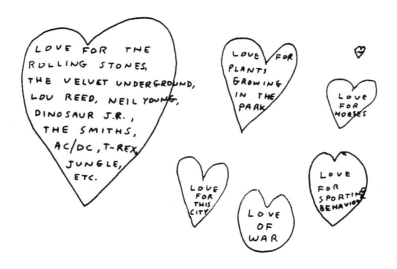

LOVE FOR THE RULLING STONES, THE VELVET UNDERGROUND, LOU REED, NEIL YOUNG, DINOSAUR J.R., THE SMITHS, AC/DC, T-REX, JUNGLE, ETC.

LOVE FOR PLANTS GROWING IN THE PARK

LOVE FOR HORSES

LOVE FOR THIS CITY

LOVE OF WAR

LOVE FOR SPORTING BEHAVIOR

THIS OFFER EXPIRES ON 30TH APRIL 1996 AND CANNOT BE USED IN CONJUNCTION WITH ANY OTHER OFFER.

'REBECCA'

'PENELOPE'

'JANE'

'VERONICA'

THE GIFT OF THE PENCIL. GIVE A CHILD AN EXPENSIVE PEN AND HE'LL PROBABLY DROP IT DOWN THE TOILET OR SOMETHING. BUT GIVE A CHILD A PENCIL AND HE CAN SCRIBBLE ALL DAY AND THEN YOU CAN GIVE HIM AN ERASER AND HE CAN RUB OUT ALL THE SWEARWORDS AND FILTH AND REPLACE THEM WITH GIRLS NAMES AND DRAWINGS OF FLOWERS.

'JULIETTE'

'SUSAN'

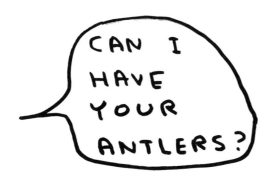

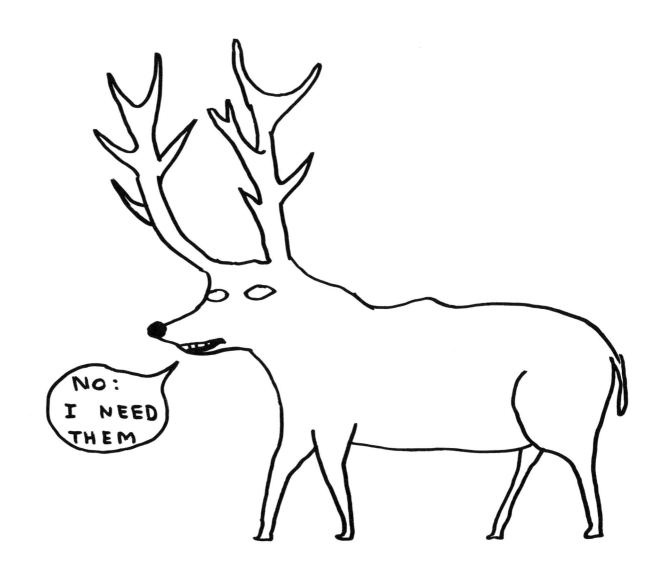

WHAT CAN I SAY ABOUT MY NEXT-DOOR NEIGHBOUR?

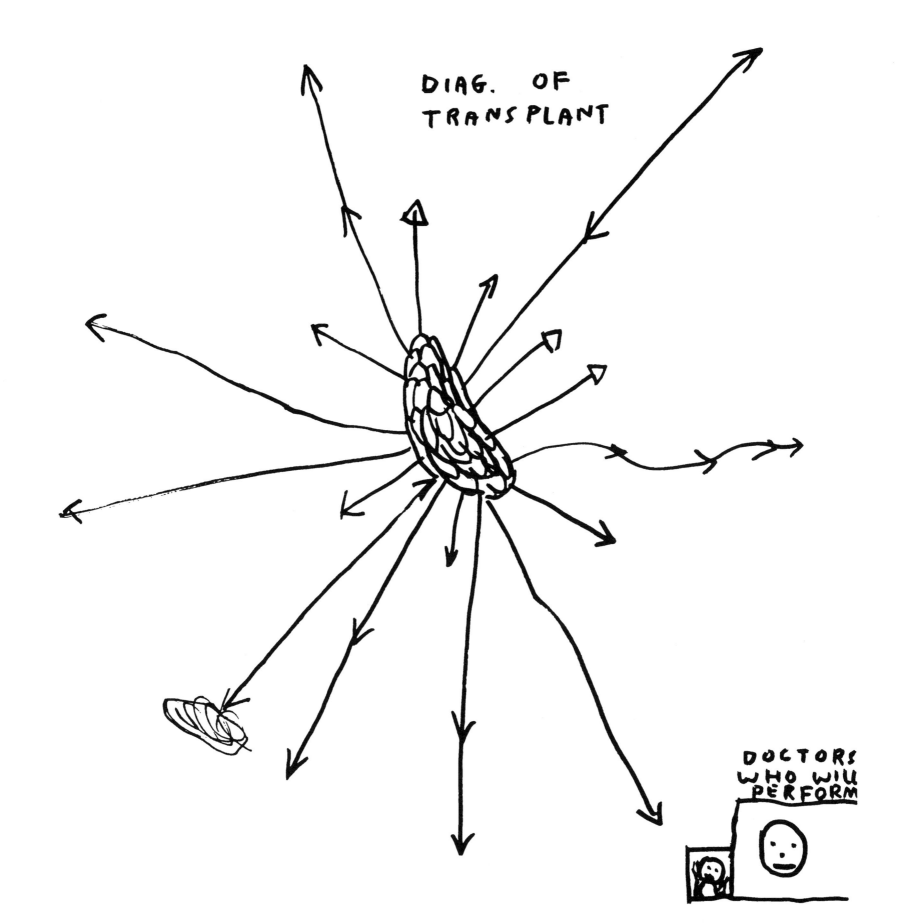

THE ARCHITECT IS ABOUT TO VOMIT

BEFORE YOU ARE SICK LET ME TELL YOU SOMETHING. I HAVE LONG BEEN AN ADMIRER OF YOUR WORK. I SPEND MY LEISURE HOURS TRAVELLING AROUND TAKING PHOTOGRAPHS OF YOUR BUILDINGS. I TAKE THESE PHOTOGRAPHS HOME AND GIVE THEM TO MY CHILDREN WHO CONSTRUCT MODELS OF YOUR BUILDINGS OUT OF CARDBOARD BOXES AND BITS OF RUBBISH. I THEN PHOTOGRAPH THESE MODELS AND SUBSTITUTE THEM FOR THE REAL PHOTOGRAPHS OF YOUR BUILDINGS IN YOUR BOOK. I GET THE BOOKS FROM LIBRARIES AND RETURN THEM AFTER I HAVE REPLACED THE PHOTOGRAPHS. I DO NOT MEAN YOU ANY DISRESPECT BY THIS. IT'S JUST A BIT OF FUN.

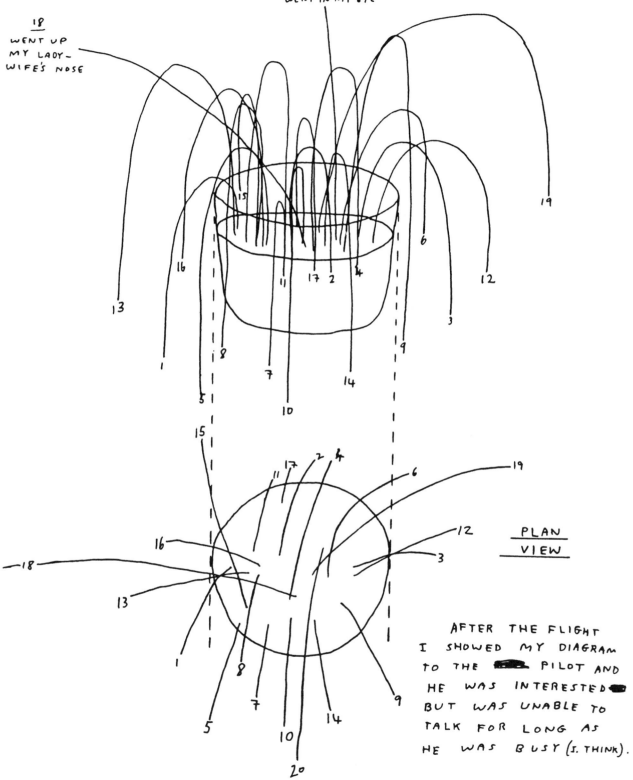

DIAGRAM SHOWING PATH OF BUBBLES FROM SPARKLING DRINK SERVED TO ME BY AIRLINE.

20
WENT IN MY EYE

18
WENT UP
MY LADY-
WIFE'S NOSE

PLAN
VIEW

AFTER THE FLIGHT
I SHOWED MY DIAGRAM
TO THE ▬▬ PILOT AND
HE WAS INTERESTED ▬
BUT WAS UNABLE TO
TALK FOR LONG AS
HE WAS BUSY (I. THINK).

MY DAD IS A DEEP SEA DIVER HE BRINGS ME GIFTS FROM THE OCEAN BED. THINGS THAT YOU CAN'T BUY IN SHOPS. THINGS LIKE SQUIDS AND CORAL AND SHARKS AND MERMAIDS AND WHALES' TEETH AND SEA SNAKES AND STARFISH AND GIANT BLUE SHELLS AND SUBMARINES AND LAND MINES AND DIVING BELLS AND SHARK CAGES AND BOUYS AND SEA HORSES AND CAR TYRES AND SALT WATER AND PLANKTON AND KRILL AND HARPOON GUNS AND ANEMONIES AND EELS AND PUFFER FISH AND SEA SCORPIONS AND BITS OF AEROPLANES AND ICEBERGS AND CRABS AND DRIFTWOOD. WE DON'T HAVE A SWIMMING POOL AT HOME BECAUSE IT REMINDS DAD TOO MUCH OF WORK. HE ALSO BRINGS SAND FOR MY SAND PIT.

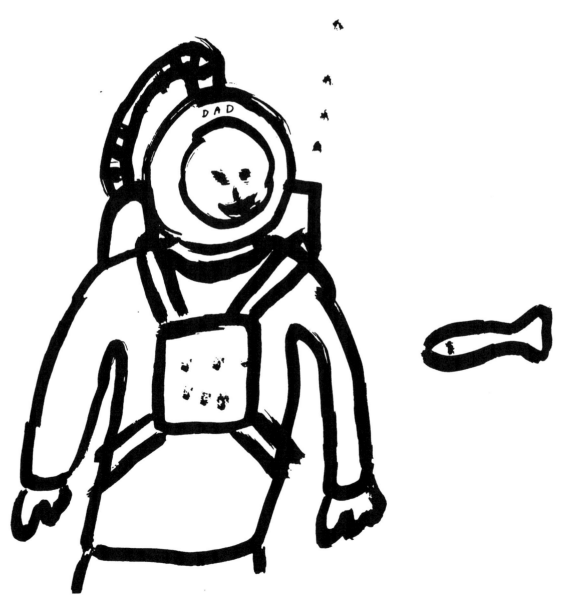

SOLUTIONS TO LAST WEEK'S PUZZLES

CROSSWORD

Across/Down letters visible:
- T R I V I A L
- I N S U B S T A N T I A L
- T E D I O U S

WORDSEARCH

```
C P R Y A D Z O K D
T B R E K Y D S U Y
I T O F H I E L M P
N U V R I T J T E I
B A J C I K L M N T
E Y Z Q S N Y Z K B
O L P D Y D G J L W
I D Y Z K E P X U Q
L P 8 K Z R O C T S
```

QUIZ

1. EASY
2. POINTLESS
3. CRAP
4. DULL
5. SAD
6. STUPID
7. IDIOTIC
8. MINDLESS
9. YAWN
10. PETTY
11. OLD LADIES
12. ETC.

CHAIN LETTERS

R	S	I
H	U	B
S	M	B

1. RUBBISH
2. RUBBISH
3. RUBBISH
4. RUBBISH
5. RUBBISH
6. RUBBISH
7. RUBBISH
8. RUBBISH
9. RUBBISH
10. RUBBISH
11. RUBBISH
12. RUBBISH
13. RUBBISH
14. RUBBISH

FAMOUS HAND

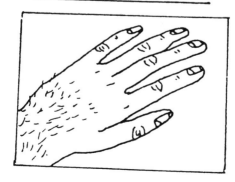

A. CLINT EASTWOOD

MYSTERY SHAPE

A. CIRCLE

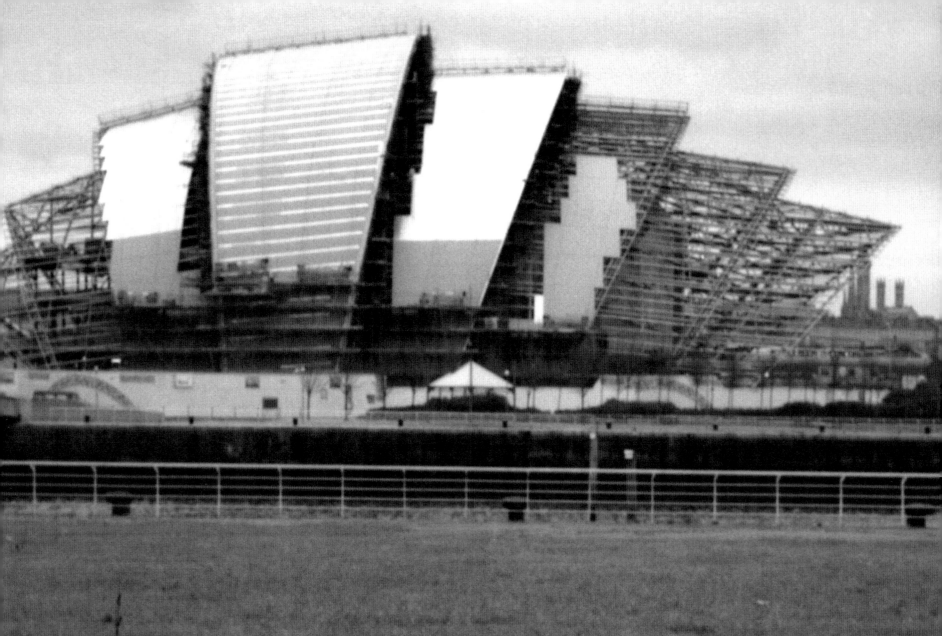

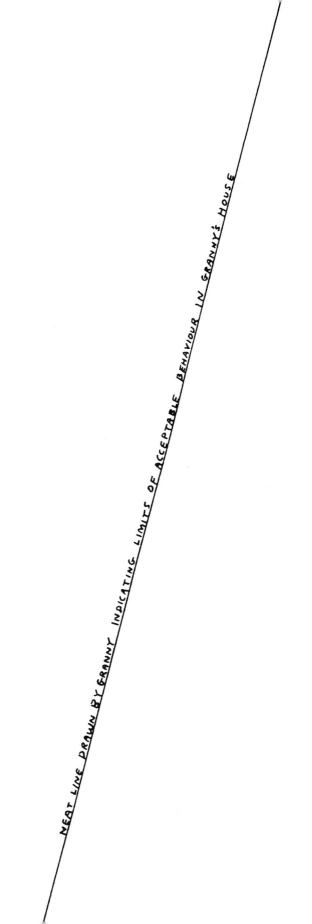

NEAT LINE DRAWN BY GRANNY INDICATING LIMITS OF ACCEPTABLE BEHAVIOUR IN GRANNY'S HOUSE

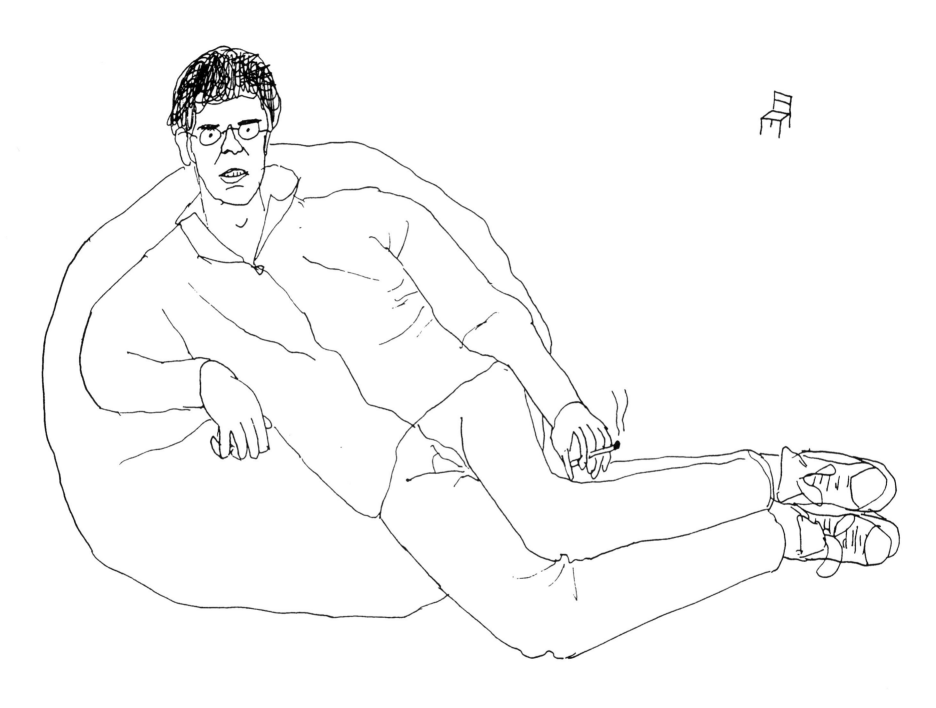

I WILL GO AND SIT ON THE CHAIR WHILE YOU LIE ON THE BEANBAG
I WILL JUMP OUT OF THE WINDOW WHILE YOU REMAIN IN THE APARTMENT
I WILL CARRY SUITCASES FULL OF HOUSEBRICKS ACROSS THE DESERT WHILE YOU MUCK ABOUT
I WILL TRY TO TYPE A LETTER OF CONDOLENCE WHILE YOU MAKE FART NOISES

NUMBERS OF THE BEASTS

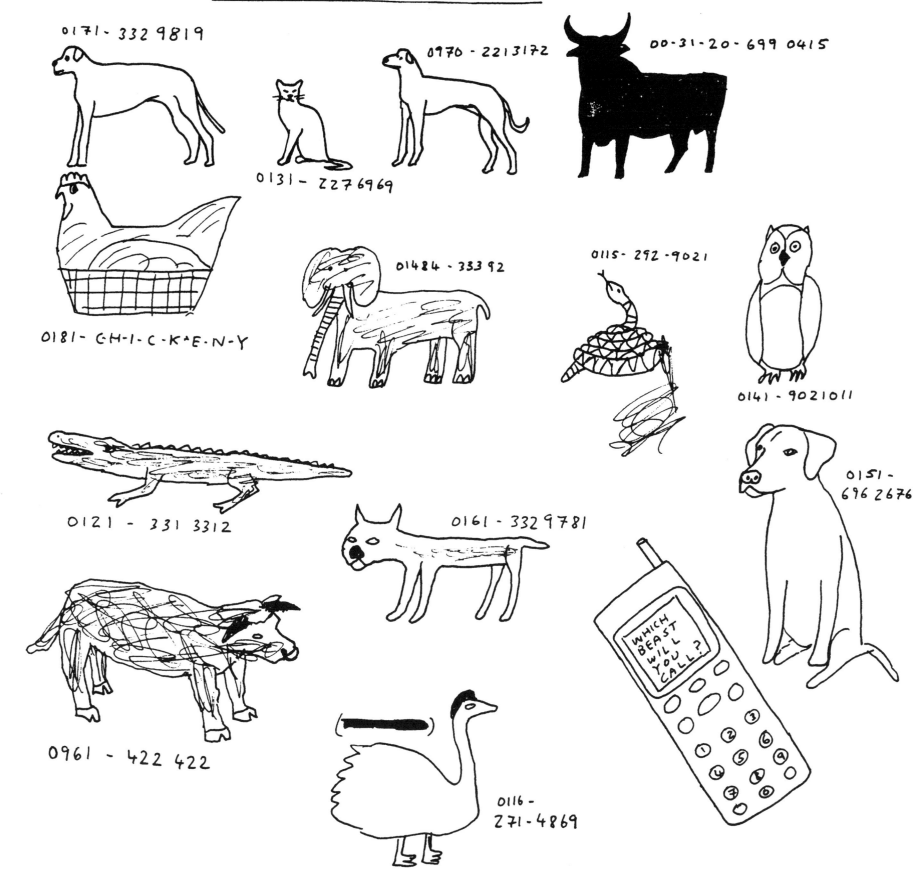

0171 - 332 9819

0131 - 227 6969

0970 - 221 3172

00-31-20- 699 0415

0181- C-H-I-C-K-*E-N-Y

01484 - 333 92

0115- 292 -9021

0141 - 9021011

0121 - 331 3312

0161 - 332 9781

0151 - 696 2676

0961 - 422 422

0116 - 271 - 4869

WHICH BEAST WILL YOU CALL?

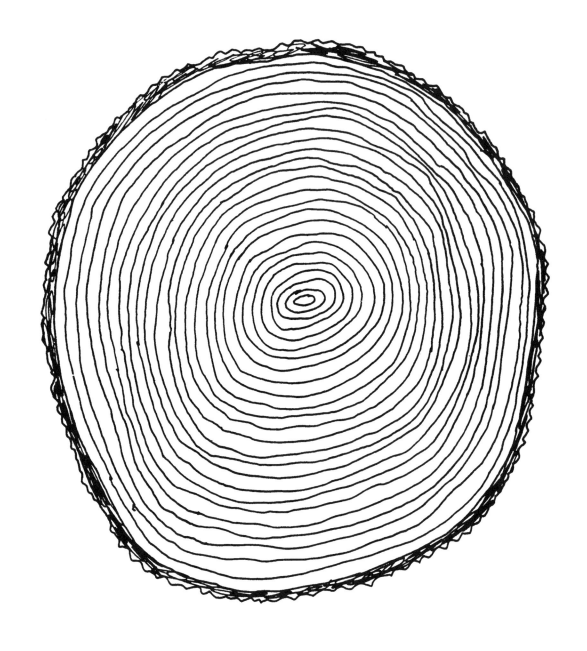

THE TREE WAS CUT DOWN BECAUSE THE INFORMATION CARVED ON IT IS NO LONGER CORRECT

THE MEASURE OF HER

SHE HAS GIVEN UP SMOKING	HER SMILE WINS		SHE PICKS FUNGI IN THE WOODS	I WISH I WAS HER	SHE HAS A TATOO	SHE HAS HER EARS PIERCED		SHE DOES NOT WEAR JEWELS (AS SUCH)	SHE LIVES IN MY HEAD AND FEEDS ON MY DREAMS		HER FANCY IS BEYOND MOST OF US	HER TOUCH GIVES ME A RASH

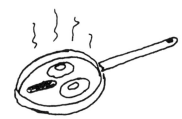

SHE LAUGHS LIKE A MANIAC BUT ONLY WHEN SHE'S HAPPY

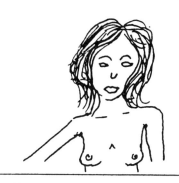

YOU WILL LOVE MY WIFE

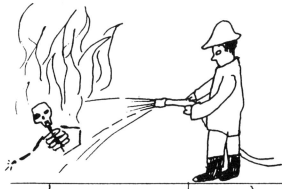

YOU WILL LOVE MY WIFE SHE IS

YOU WILL LOVE MY WIFE SHE IS BRILLIANT

SOMETIMES I WISH I WAS STILL A CHILD BUT WHEN I AM WITH HER (IN THE BIBLICAL SENSE) I AM ACUTELY AWARE OF MY ADULT STATUS

SHE KISSES INANIMATE OBJECTS AND LIKES THE ROLLING STONES

SHE LOVES CARTOONS

I AM NEVER ALONE BECAUSE MY JACKET IS SEWN WITH LOCKS OF HER HAIR

SHE IS MORE BEAUTIFUL THAN THE MOST BEAUTIFUL HORSE

I AM LUCKY BECAUSE I AM ALLOWED TO WATCH HER SLEEP. HER BEDROOM IS NEXT TO MINE.

WHEN MY PARENTS WENT TO THE MUSEUM THERE WAS A LOT OF STUFF THAT THEY DIDN'T LIKE ALSO A LOT OF THE PAINTINGS WERE HUNG TOO HIGH FOR THEM TOO SEE (THEY HAVE BEEN PROGRESSIVELY SHRINKING SINCE I LEFT HOME).

ARCHITECTURE
MAGAZINE NO.1

FREE TOOL

THIS ISSUE:
FANCY NEW
STRUCTURE BURNS

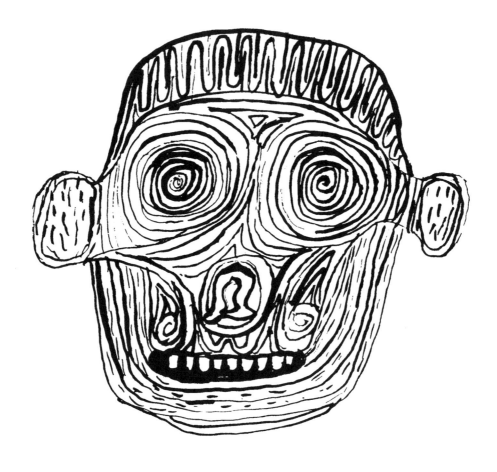

ROB WHEN HE WAS OFF HIS HEAD

LITTLE KIDS ON THE TRAIN, TRAVELLING LONG DISTANCES, ACROSS CONTINENTS, ALONE

GOOD	NAUGHTY
	SARAH (JOHANNESBURG — COPENHAGEN)
KEITH (LONDON — INDIA)	NICK (LIMA - NEW YORK CITY)
WEE BRUCE (TORONTO - MEXICO CITY)	INGRID (MARSEILLE - BANGKOK)
SOLÈNE (PARIS - JERUSALEM)	MUARA (ROTTERDAM - COLOMBO)
ALI (DURBAN - HYDERABAD)	
DONALD (SANTIAGO - ANCHORAGE)	AND OTHERS

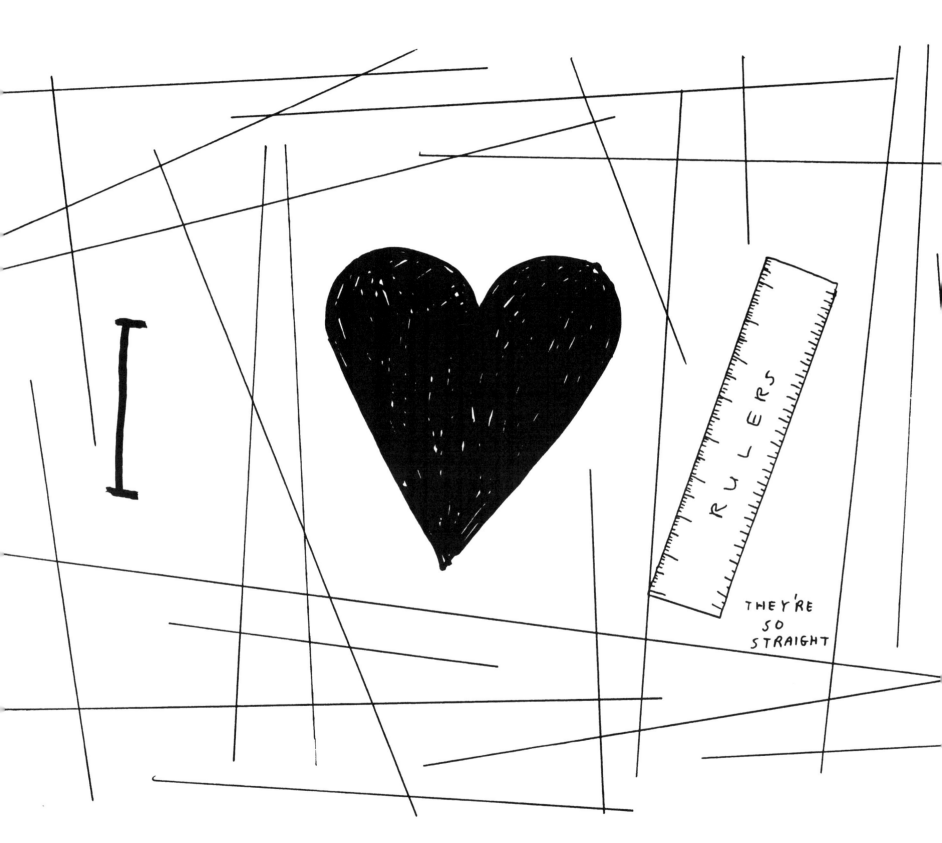

I ♥ RULERS

THEY'RE SO STRAIGHT

THE DUNG ARE
ELATED AS THEY
LEARN THE NATURE
OF THEIR PRIZE

CUP OF TEA FOR SALE

£100 (OR NEAR OFFER)

GOOD CONDITION. MILK , 2 SUGARS

THE WORLD IS NOT A BEAUTIFUL PLACE

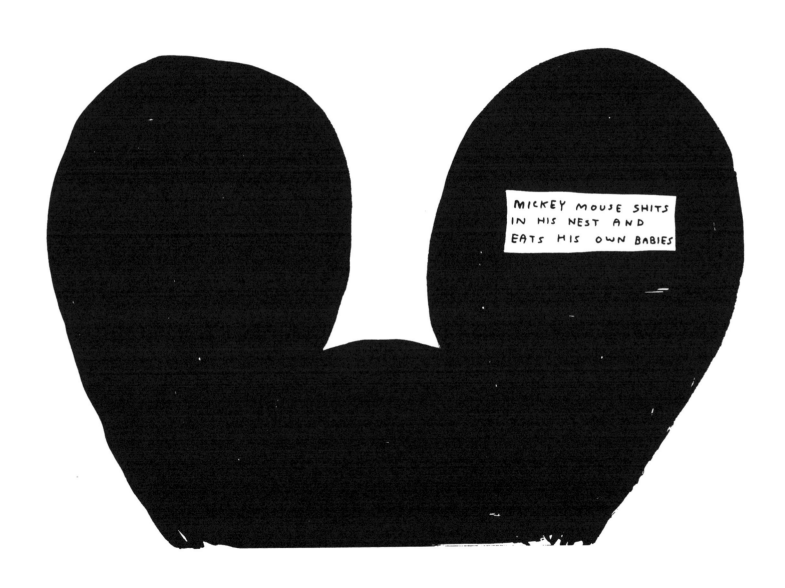

MICKEY MOUSE SHITS
IN HIS NEST AND
EATS HIS OWN BABIES

THIS STONE WAS DIRTY ~~WAS~~ WHEN WE FOUND IT AND IT'S STILL DIRTY NOW — WE HAVEN'T CLEANED IT. IT CONTAINS NO FOSSILS, NO MINERALS OR GOLD OR ANYTHING LIKE THAT (BUT ~~WE~~ WE DON'T REALLY KNOW BECAUSE WE HAVEN'T LOOKED). WE HANG ABOUT IN CAR PARKS AND USE IT TO SMASH WINDSCREENS SO WE CAN STEAL CAR STEREOS.

NAKED IS BAD

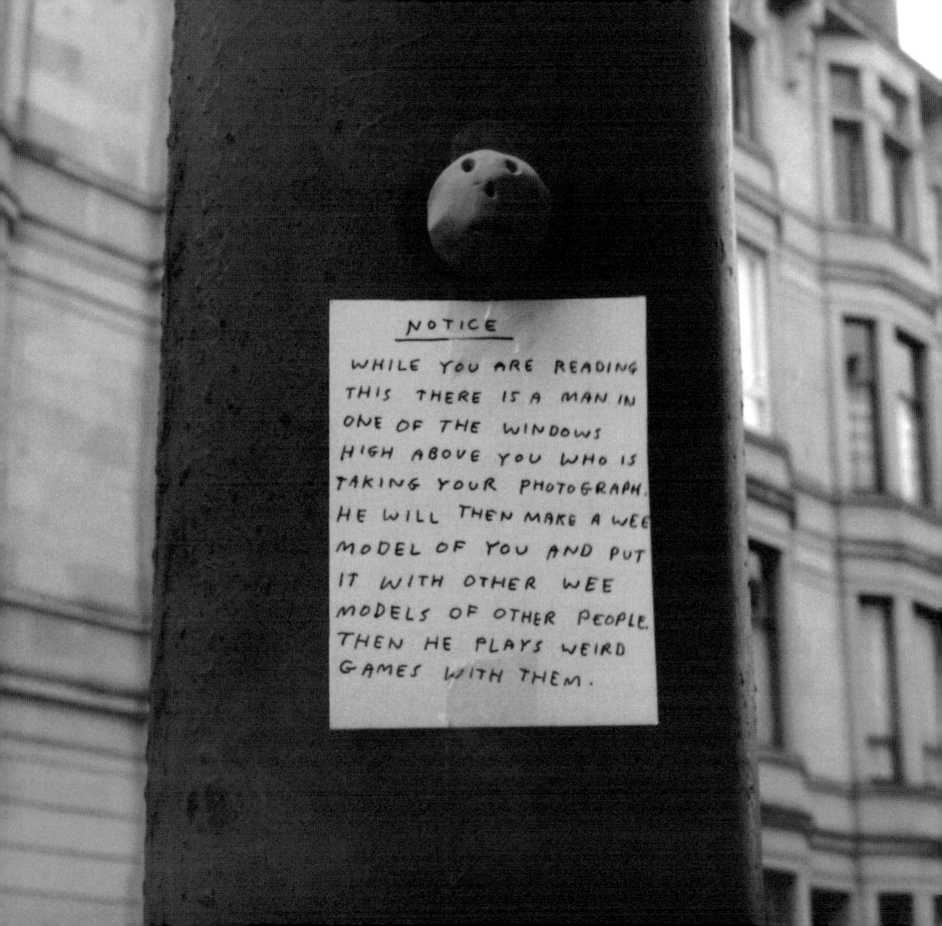

SPORES 'N' SORES

THE TERRIBLE CARBUNKLES ▬ THAT YOU HAVE
ON YOUR BACKSIDE AND I HAVE ON MY NOSE
ARE CAUSED BY SPORES SUCH AS THESE. BUT
THERE IS NO NEED FOR YOU TO WORRY AS
I HAVE SORTED OUT A REMEDY. JUST YOU SIT
BACK AS COMFORTABLY AS CAN AND I'LL NIP
DOWN TO MY LABORATORY TO FETCH IT. HELP
YOURSELF TO SOME OF MY COCAINE WHILE I'M GONE.

MY TEACHER IS NOT A GHOST, HE IS A REAL PERSON.

MY TEACHER IS NOT A GHOST, HE IS A REAL PERSON.

MY TEACHER IS NOT A GHOST, HE IS A REAL PERSON.

MY TEACHER IS NOT A GHOST, HE IS A REAL PERSON.

MY TEACHER IS NOT A GHOST, HE IS A REAL PERSON.

MY TEACHER IS NOT A GHOST, HE IS A REAL PERSON.

MY TEACHER IS NOT A GHOST, HE IS A REAL PERSON.

MY TEACHER IS NOT A GHOST, HE IS A REAL PERSON.

MY TEACHER IS NOT A GHOST, HE IS A REAL PERSON.

MY TEACHER IS NOT A GHOST, HE IS A REAL PERSON

MY TEACHER IS NOT A GHOST, HE IS A REAL PERSON

MY TEACHER IS NOT A GHOST, HE IS A REAL PERSON

MY TEACHER IS NOT A GHOST, HE IS A REAL PERSON.

MY TEACHER IS NOT A GHOST, HE IS A REAL PERSON.

MY TEACHER IS NOT A GHOST, HE IS A REAL PERSON.

MY TEACHER IS NOT A GHOST, HE IS A REAL PERSON.

MY TEACHER IS NOT A GHOST, HE IS A REAL PERSON.

MY TEACHER IS NOT A GHOST, HE IS A REAL PERSON.

MY TEACHER IS NOT A GHOST, HE IS A REAL PERSON.

MY TEACHER IS NOT A GHOST, HE IS A REAL PERSON.

YOU WOULD NOT ~~believe~~ BELIEVE THE
REASON FOR MY BEING SO LATE I WAS
~~███████ ███████ ███████ ███████ ███████ ███████ ███████ ███████~~
~~███████ ███ ███████ ███ ███ ███████ ███████ ███~~
~~███ ███████ ███████ ███████ ███████ ███████ ███~~
~~███ ███████ ███████ ███████ ███████ ███████ ███~~
~~███ ███████ ███ ███████ ███████ ███████ ███~~
~~███ ███████ ███ ███████ ███████ ███ ███ ███~~
~~███████ ███████ ███████ ███████~~

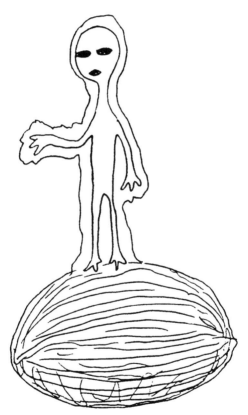

IT WAS SO BEAUTIFUL THAT I
COMPLETELY FORGOT THE TIME.

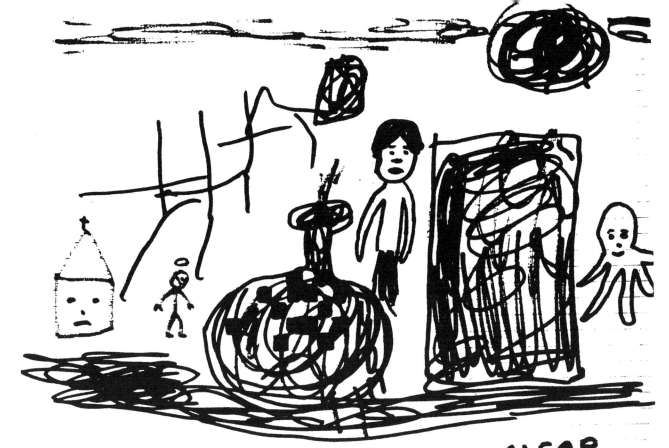

MY HOUSE IS NEAR A NUCLEAR POWER PLANT AND I CAN'T GROW ▮▮▮ ▮▮ ANYTHING IN MY GARDEN. MY HOUSE USED TO BE NEAR A MILITARY INSTALLATIO AND THEY BOMBED MY GARDEN BY MISTAKE. BEFORE THAT MY HOUSE WAS IN AFRICA AND A HERD OF RHINOCEROSES CAME AND TRAMP-LED MY GARDEN. BEFORE THAT I USED TO LIVE IN A FLAT. ▮▮ BEFORE THAT MY HOUSE WAS NEXT DOOR TO A BUNCH OF TROUBLEMAKERS.

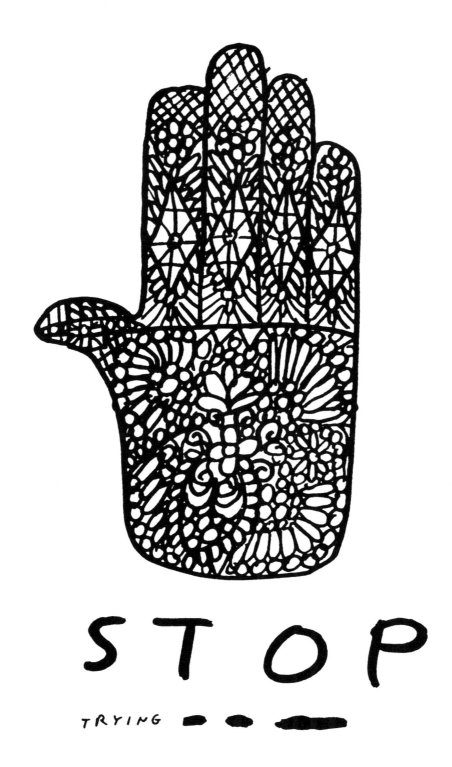

STOP

TRYING ▬ ▪ ▪ ▬▬

WHERE ARE THEY?

1. MUM AND DAD ARE DOWNSTAIRS WATCHING 'LAST OF THE SUMMER WINE'

2. DAVID IS UPSTAIRS IN HIS ROOM DRAWING PICTURES OF TORTURE AND SATAN.

WHAT WILL THEY DO NEXT?

1. MUM AND DAD WILL EAT SOME CRISPS AND THEN WATCH 'TWO POINT FOUR CHILDREN'

2. DAVID WILL CONTINUE HIS SCHOLARLY ACTIVITIES UPSTAIRS

AND AFTER THAT?

1. MUM AND DAD WILL DRINK GINGER WINE AND THEN WATCH THE FILM.

2. DAVID WILL SACRIFICE A GOAT AND THEN GO DOWNSTAIRS AND WATCH THE FILM ALSO.

Mystic Tit

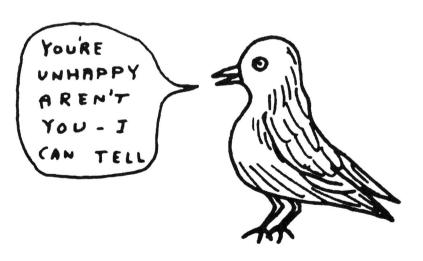

ARTISTS TALK ABOUT THEIR WORK

I DON'T ACTUALLY DO THE PAINTINGS MYSELF, I GET A BUNCH OF HANDICAPPED KIDS TO DO THEM FOR ME....

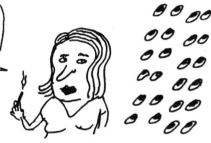

I USE A LOT OF FOUND MATERIALS IN MY WORK. MY LATEST PIECE IS FIFTY IDENTICAL PAIRS OF CHILDRENS SHOES WHICH I FOUND IN A CHARITY SHOP THEY'RE BRILLIANT AND THEY ONLY COST £30.

I WENT AROUND TOWN AND ASKED DOSSERS IF I COULD BUY THEIR UNDERPANTS FROM THEM. I GOT SIX PAIRS FOR £5 EACH AND USED THEM FOR MY SHOW IN FRANCE.

I GO AROUND BARS AT THE WEEKENDS AND DELIBERATELY GET INTO FIGHTS AND GET MY HEAD KICKED IN WHILE A FRIEND OF MINE VIDEOS IT.

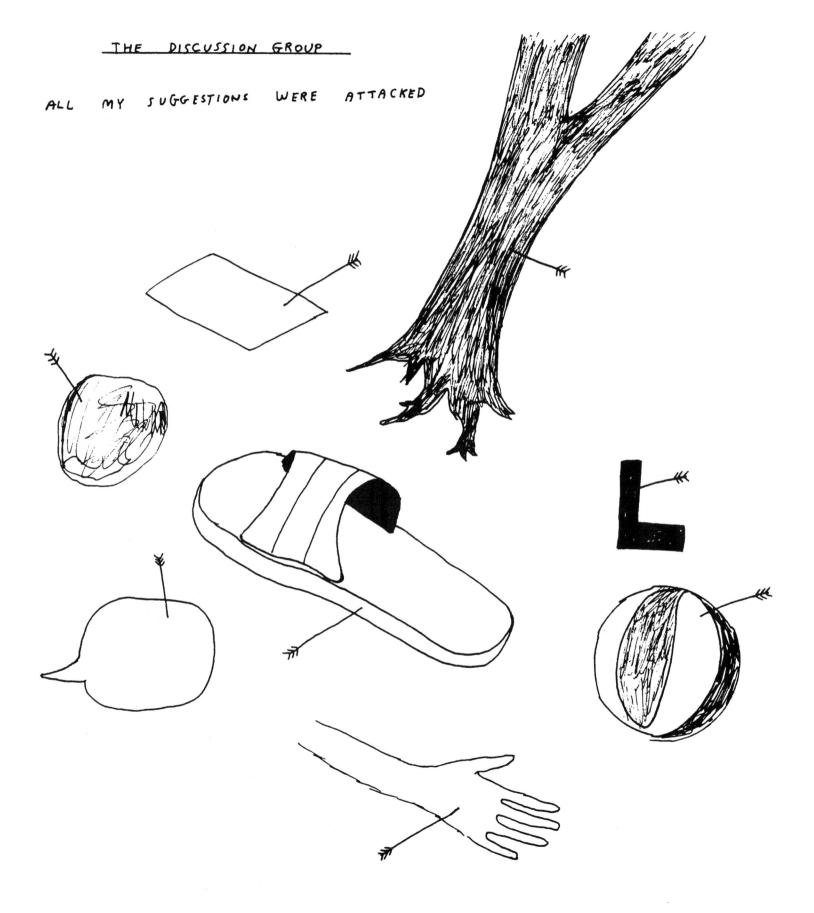

DIARY DATES

SEPT 7 CHILDRENS WORKSHOPS

 8 RACIAL JUSTICE SUNDAY

 14 PRAYERS FOR GRAND PRIX

 14 HOLY CROSS SERVICE AT CHICHESTER CATHERDRAL

 14 HUMAN SEXUALITY STUDY ~~—~~ DAY

 17 PRAYER VIGIL FOR OLD ~~—~~ BITS OF CAR TYRE ON THE MOTORWAY.

OCT 2 COCA-COLA CUP 2ND ROUND 1ST LEG

 6 PILGRIMAGE TO OLD HUT IN WOODS

 25 SIGNS OF LIFE DAY CONFERENCE

 28 'HOW ~~—~~ ARE WE SUPPOSED TO KNOW THAT WHAT WE ARE DOING IS RIGHT?' – DAY CONFERENCE

 30 PILGRIMAGE TO SCRAP YARD TO FIND BREAK SPRINGS FOR 1977 LONG WHEEL BASE $2\frac{1}{4}$ DIESEL LAND ROVER

NOV 1 BANK HOLIDAY (EVERWHERE INCLUDING HERE)

 3 PRAYER VIGIL FOR BAGS OF SAND IN NEXT-DOOR NIEGHBOURS GARDEN

 10 ECUMENICAL EVENT IN OLD WAREHOUSE NEAR TO RIVER

 13 BIKE/WALK EVENT

 16 FAMILY STUDY DAY

ENTRIES FOR NEXT ISSUE SHOULD REACH THE EDITOR BY 7 NOVEMBER.

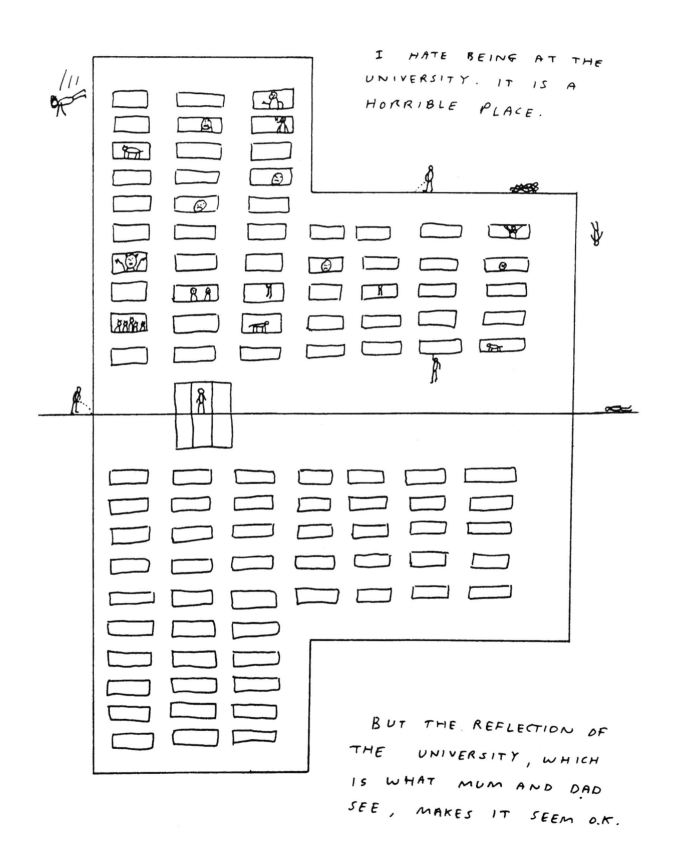

I HATE BEING AT THE UNIVERSITY. IT IS A HORRIBLE PLACE.

BUT THE REFLECTION OF THE UNIVERSITY, WHICH IS WHAT MUM AND DAD SEE, MAKES IT SEEM O.K.

NO LASTING IMPRESSION MADE ON ME BY MUCH ANYMORE (EXCEPT PARACHUTING)

NO HANDLES ON TEACUPS OVERSEAS

NO KNOBS ON STATE OF THE ART EQUIPMENT

NO LEAVES ON THE TREES. EVEN IN THE SPRINGTIME.

NO TRACTORS ON FOOTPATH. THANK-YOU

NO MORE MORE SPACE TRAVEL FOR NAUGHTY ASTRONAUGHT

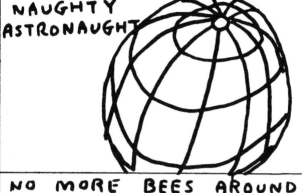

NO SQUASHED FLIES ON WINDSCREEN, NOT ANYMORE, NOT NOW FIDO HAS BEEN LICKING IT ALL AFTERNOON.

NO HAIRCUT FOR BIGNOSE

NO MORE BEES AROUND HONEYPOT. NOT NOW HONEYPOT IS FILLED WITH TURPENTINE.

NO MORE ▬ ROMANTIC WALKS IN THE PARK WITH YOUR NEW BOY-FREIND. NOT NOW SNIPER IS AT LARGE.

NO TRYING TO HAVE AN INTELLIGENT CONVERSATION WITH ME BEFORE BREAKFAST.

NO MORE TREATS NOT NOW NOT EVER

THE TRUTH ABOUT THE
LIBRARY

* ALL THE BULLSHIT IS RECORDED IN A GIANT LOG BOOK.

(IT STINKS SO MUCH IT HAS TO BE KEPT IN A SPECIAL ROOM.)

* BOOKS ABOUT LOVE NO LONGER AVAILABLE.

* BOOKS ABOUT TRUST + TRUTH NOT TO BE LENT TO CHILDREN.

* BOOKS ABOUT PLANTS BURIED IN 1960's BY ECCENTRIC.

* BOOKS ABOUT ANIMALS KEPT IN SMALL DUNGEON.

* BOOKSHELVES WITH NOTHING ON THEM BUT DUST.

* LIBRARIAN CARRIES KNIFE.

* AFTER HOURS LIBRARY IS USED AS MEETING PLACE FOR SHE-MEN AND OTHER ODD TYPES.

SPECIALITIES OF THE HOUSE

INTESTINES

FLIES

HEADS

HAIRS

BLACK SHEEP

ALL SERVED IN THIS MODERN

BUILDING BY PROFESSIONAL

WAITERS

HEADLINES

PUBIC TORNADO COVERS HOUSE IN SMALL HAIRS

FORMER EDFE OF PAGE

I RECEIVED THIS IN THE POST THE OTHER DAY;

CAR WITH ONE BIG HEADLIGHT

I'M REALLY WORRIED ABOUT IT.

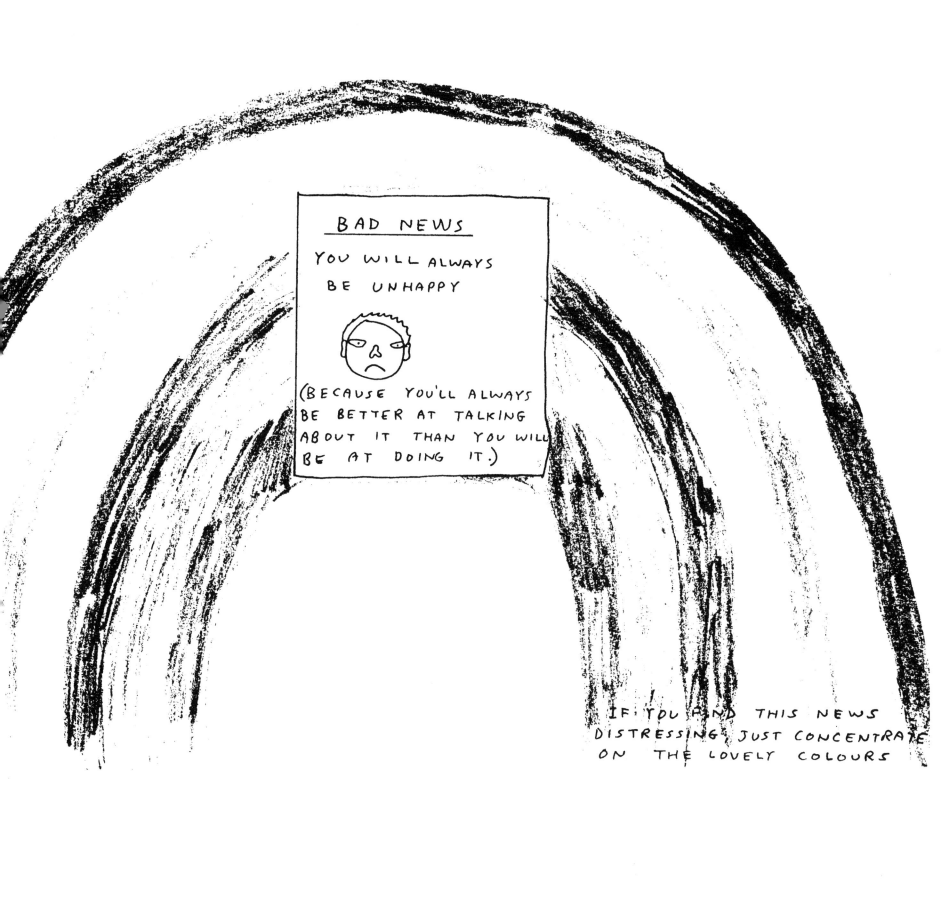

ON THE FIRST DAY OF MY WORK IN THE POOREST AREA OF TOWN I SUMMONED ALL OF THE LOCAL RESIDENTS TOGETHER ON A PIECE OF WASTE LAND. THERE I MADE THEM POSE FOR A HUGE PAINTED GROUP PORTRAIT. I SET UP MY EASEL AND BEGAN TO WORK. BY THE END OF THE NINTH DAY THE PAINTING WAS FINISHED. UNFORTUNATELY ONE OF THE OLD PEOPLE HAD DIED OF EXPOSURE BY THIS TIME. THE PAINTING NOW HANGS IN THE LOCAL COMMUNITY CENTRE. YOU CAN RECOGNISE THE ONE THAT DIED BECAUSE I PAINTED ~~TEAM~~ HIM WITH A BLUE FACE.

REACTIONS OF
YOUR FAMILY
WHEN YOU TOLD
THEM YOU WERE
GAY (BUT YOU WEREN'T
REALLY (OR WERE YOU?))

AFTERS

AFTER THE SUN HAS GONE DOWN

AFTER THE MOON ~~███~~ HAS COME UP

AFTER THE CHAIRS HAVE BEEN PUT
BACK IN THEIR POSITIONS

AFTER THE GIN HAS BEEN FINISHED

AFTER MY DRAWINGS HAVE BEEN SOLD

AFTER YOU HAVE PAID FOR DINNER

AFTER I HAVE WASHED THE DISHES

AFTER WE HAVE KISSED

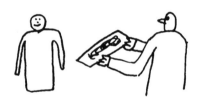

AFTER WE HAVE ARM—WRESTLED

AFTER THE STARS HAVE APPEARED IN
THE NIGHT SKY LIKE A BLACK CAT
WITH DANDRUFF

THEN AND ONLY THEN WILL IT
BE TIME FOR ~~███~~ BED .

EXCELLENT NEWS

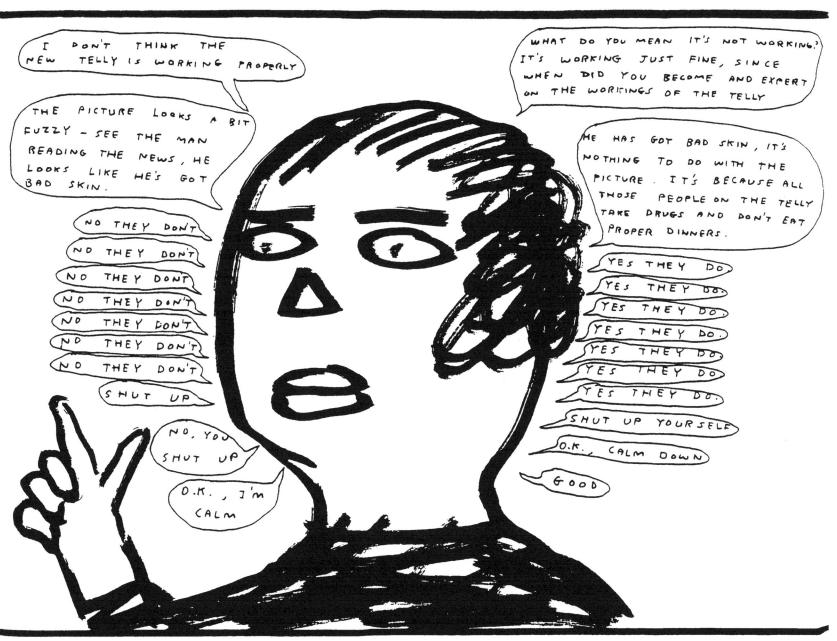

DAD HAS GONE MAD AND STARTED TALKING TO HIMSELF WHICH MEANS THEY'LL TAKE HIM AWAY WHICH MEANS THEY'LL BE MORE FOOD FOR THE REST OF US AND WE CAN WATCH WHATEVER WE WANT ON T.V.

GOOD LUCK

IN THE STRANGE
AND BRUTAL KINGDOM
YOU CALL HOME.

"DAD"

"MUM"

SIMPLE ~~[redacted]~~ ADVERTISING TOOL
MADE ME BUY HIDEOUS MUCK

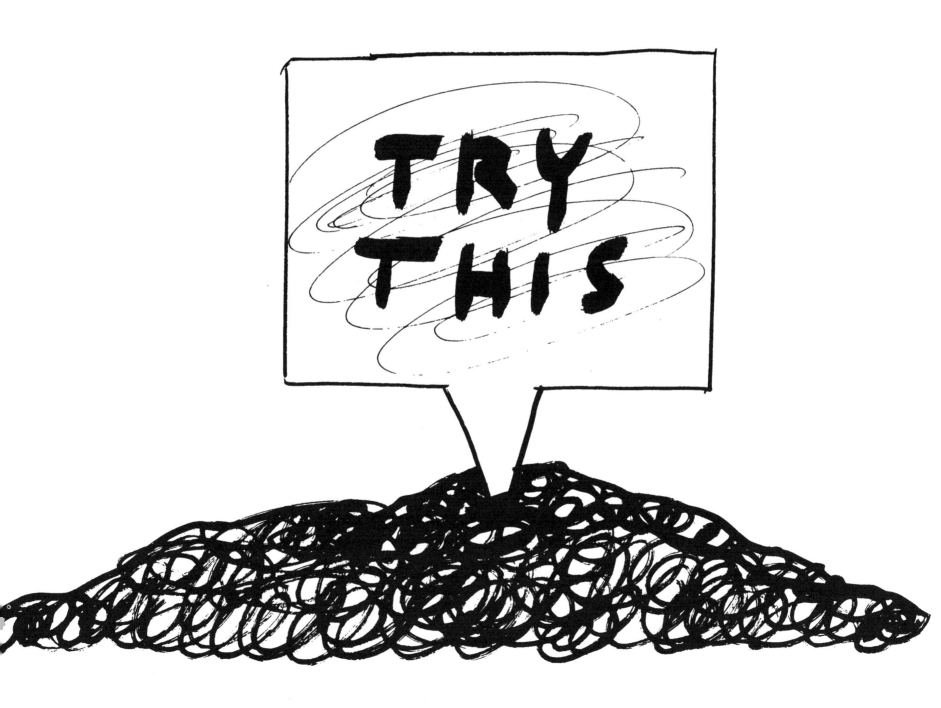

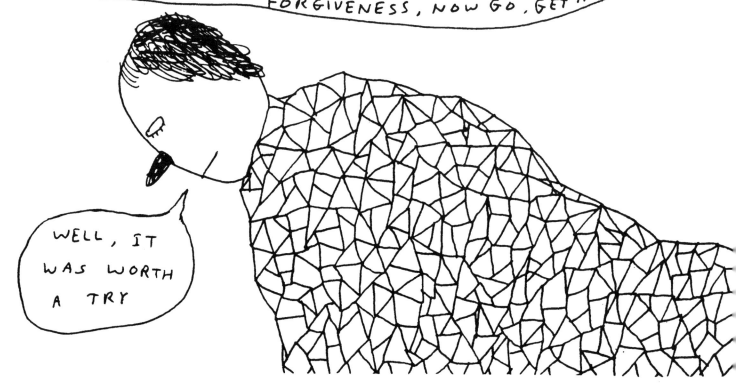

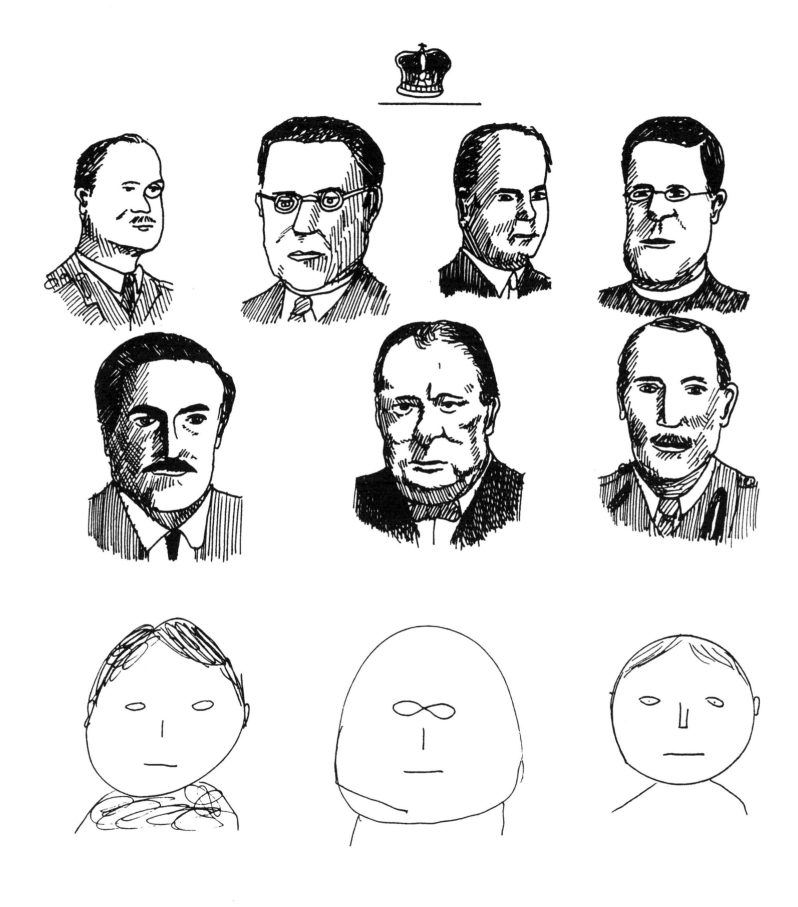

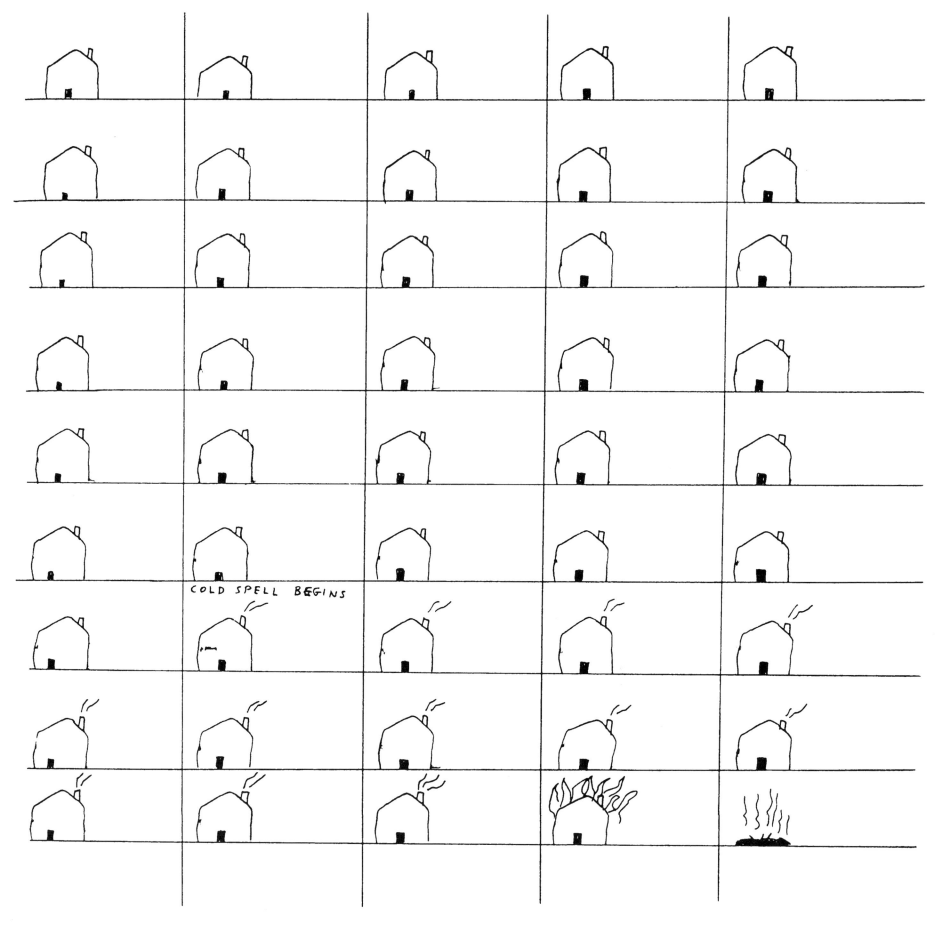

COLD SPELL BEGINS

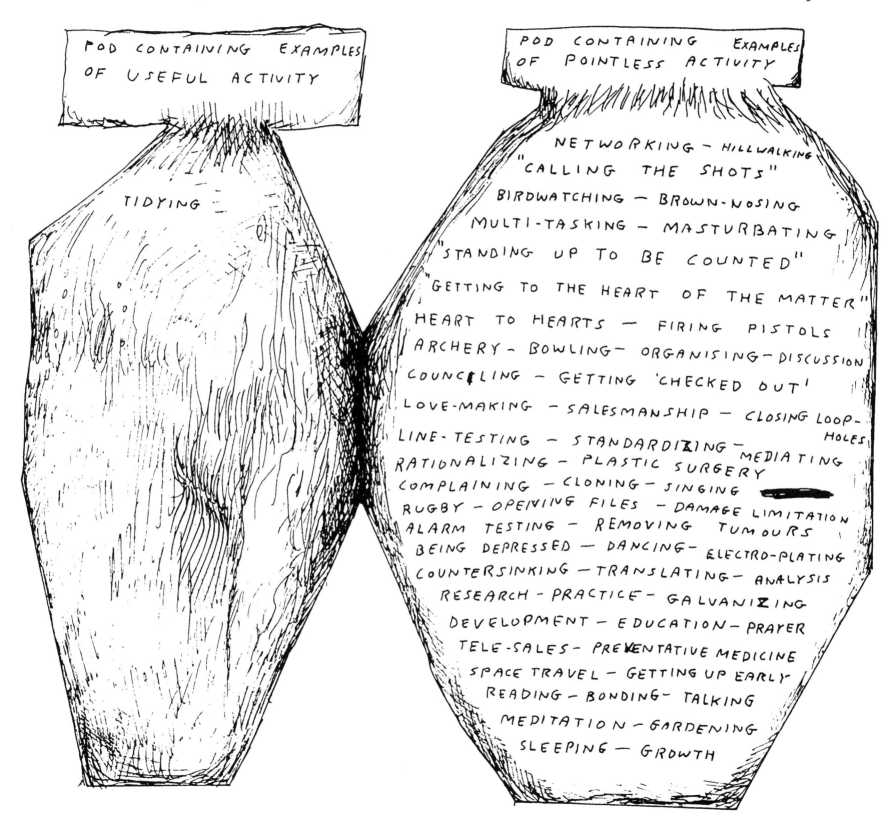

BAD TIME ON THE GRASS

WE WERE ON THE GRASS AND WE HAD A REALLY BAD TIME. FIRST WORMS CAME UP THROUGH THE SOIL AND WRAPPED THEMSELVES AROUND US. THEN BIRDS CAME DOWN TO GET THE WORMS AND PECKED US. THEN A MOLE CAME UP AND IGNORED US (THIS WAS NOT SO BAD). THEN SLUGS AND SNAILS CAME AND COVERED US IN FILTH. THEN A DOG CAME AND FOULED ON US. THEN IT STARTEDTORAIN ■. THEN THE GRASS WAS MOWED (I DON'T KNOW HOW WE SURVIVED). THEN POISONOUS PESTICIDES WERE USED TO KILL THE WEEDS (WHICH HAD BEEN OUR FOOD). THEN IT RAINED EVEN MORE AND THE GRASS WAS FLOODED, THE WORST FLOODS FOR 100'S OF YEARS. THEN A MAN CAME AND TOLD US TO GET OFF THE GRASS. THEN WHEN I GOT HOME I FOUND I ONLY HAD £5 LEFT IN MY WALLET AND IT HAD TO LAST UNTIL THURSDAY.

I PISSED DOWN THE CHIMNEY OF THE DOLL'S HOUSE
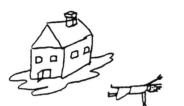

I CUT OFF THE CAT'S WHISKERS

I DREW ON YOU WHILE YOU WERE ASLEEP

I POINTED THE FINGER WHEN I SHOULD HAVE KEPT MY MOUTH SHUT.
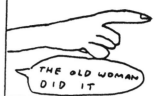

THE OLD WOMAN DID IT

I'M SORRY

I PRETENDED TO BE A PRIEST FOR BOB'S LAST CONFESSION AND NOW HIS SOUL RESIDES IN THE PLACE OF TORMENT

I RELEASED THE FLIES
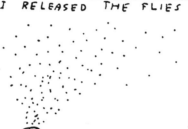
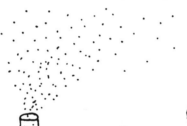

I SUMMONED THE DEVIL AND NOW YOU CAN'T GET RID OF HIM
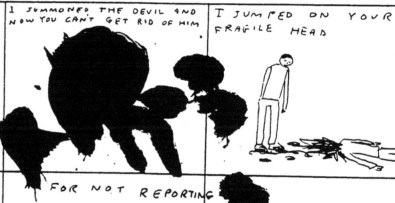

I JUMPED ON YOUR FRAGILE HEAD

FOR ENCOURAGING MY DOG TO CHEW THROUGH THINGS.

FOR RECORDING OUR CONVERSATIONS (SECRETLY)

FOR NOT REPORTING THE FIRE

FOR SPENDING ALL MY MONEY ON ALE

FOR LYING TO MY PATIENTS
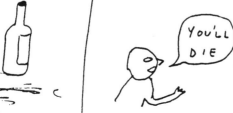

YOU'LL DIE

FOR THE MAYHEM I HAVE CAUSED WITHIN THE DISABLED COMMUNITY. FOR ALL THE SIGNAGE I HAVE TAMPERED WITH. FOR ALL THE MECHANICAL DEVICES I HAVE RENDERED USELESS. FOR ALL MY SPITEFUL INTERFERENCE IN PUBLIC SERVICES. FOR ALL THE SMALL CREATURES I HAVE TORTURED AND KILLED. AND FOR MY COWARDLY PERSECUTION OF THE WEAK AND DEFENCELESS.

I AM ALSO SORRY FOR A GREAT MANY OTHER THINGS TOO NUMEROUS TO BE LISTED ON ONE PAGE. FOR A COMPLETE CHRONOLOGY SEND A STAMPED, ADDRESSED ENVELOPE (A4) TO OFFICE ADDRESS PRINTED ON REVERSE.

AS I COME TO THE END OF MY CAREER

I AM HAVING A DREAM IN WHICH I AM ABOUT TO DIE AND ENTER THE NETHER-WORLD. ALL THE CRAP OBJECTS I HAVE ██ MADE SUDDENLY SURROUND ME AND START ASKING AWKWARD QUESTIONS.

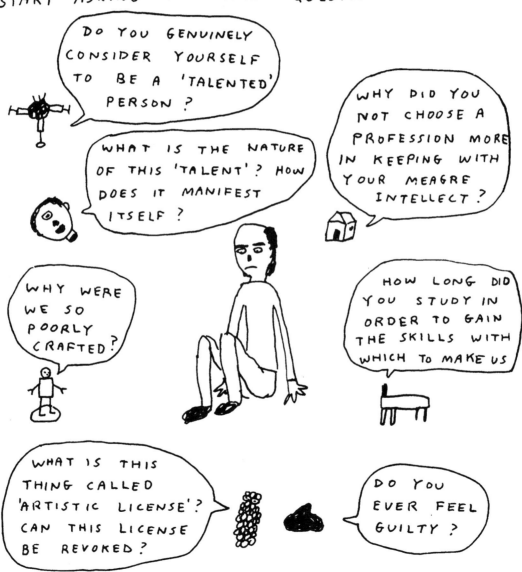

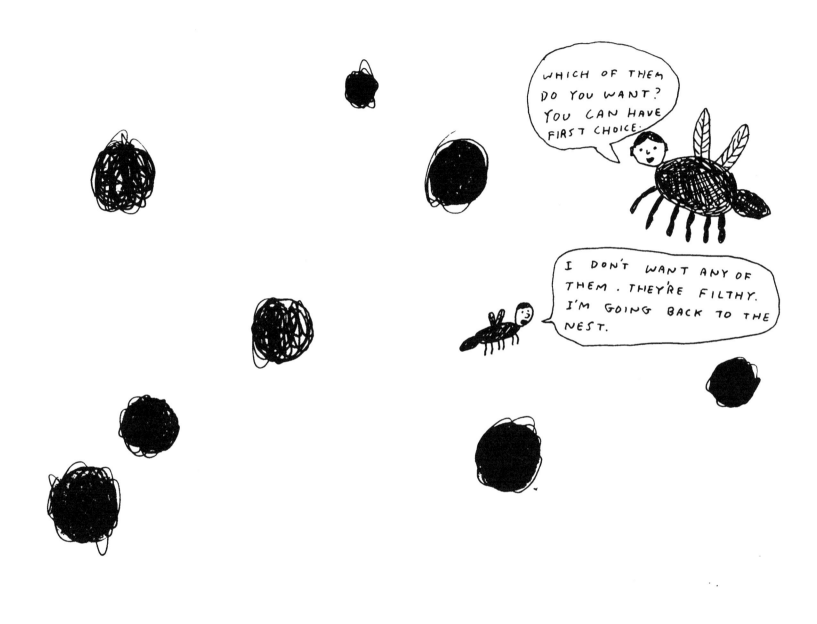

WHY DO YOU FIND MY DRAWINGS SO ANNOYING? ARE YOU SOME KIND OF
MORON WITH FREAKISH TASTES? EVERYONE ELSE LIKES THEM, SO
WHY DON'T YOU? JUST TRYING TO BE DIFFERENT, EH? I ALWAYS
KNEW YOU WERE A TWAT.

THE ~~XXXX~~

IF YOU WANT
TO GET REALLY
HYPNOTIZED
USE THIS
CARD

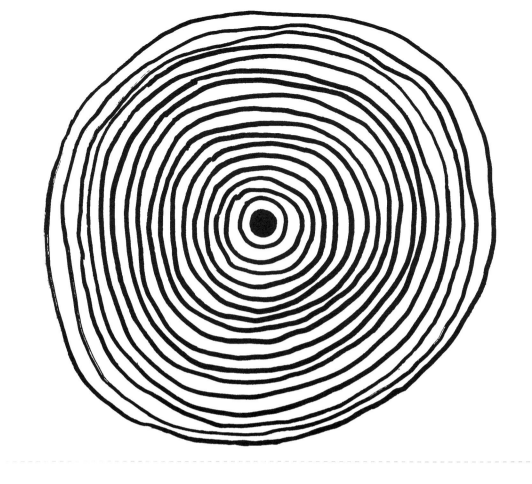

IF YOU WANT
TO GET JUST
A BIT
HYPNOTIZED
USE THIS
CARD

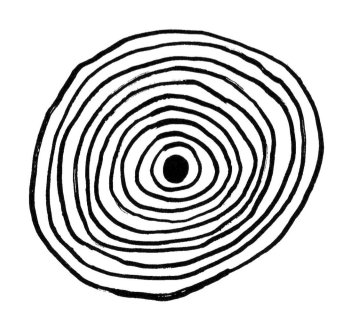

QUIZ

WHAT DO
ELEPHANTS KEEP
BEHIND THEIR EARS?

IF YOU WANT
TO RELAX
FOR A BIT
JUST LOOK
AT THIS
FOR A WHILE

IF YOU
WANT TO
REMAIN AS
YOU ARE
USE THIS.

A. POSTERS,
LETTERS, ████████
PHOTOS, DOCUMENTS,
MAPS : ALL KEPT
IN A PLASTIC WALLET.

'FALSE LEAF'

USE TO PROMOTE 'FALSE AUTUMN'

PLACE OUTSIDE, NEAR A TREE

CONGRATULATIONS ON YOUR FANTASTIC ACHIEVEMENT

QUIZ

Q. WHAT IS SKINNY PETE SITTING ON?

FOLD

ME AND YOUR MOTHER DON'T
UNDERSTAND WHAT IT IS YOU'RE
SUPPOSED TO HAVE DONE OR
WHAT'S GOOD ABOUT IT BUT
YOU'RE A NICE LAD SO WELL
DONE ANYWAY.

ANSWER

A. SKINNY PETE
IS SITTING ON
DAMP GRASS.

QUIZ

Q. WHAT ARE
THE PEOPLE AT
THE HOSPITAL
BURNING ?

Q. WHAT IS
GRANDMA BURNING?

KEEP THESE CARDS IN YOUR HANDBAG FOR REFERENCE PURPOSES

IMAGINE
THIS FINGER
IS POINTING
AT YOU

THE BEADED CURTAIN

NO

YES

ANSWERS

A. THE PEOPL
AT THE HOSPI
ARE BURNING
BODY - PARTS
BED LINEN,
ABORTED FOETU
~~━━━━━━━~~

A. GRANDMA
IS BURNING
MY LETTER.

THE ALL-SEEING EYE

IT SHOULD BE REMEMBERED THAT THERE ARE CERTAIN THINGS THAT THE ALL-SEEING EYE ● IS UNABLE TO SEE;

1. THINGS THAT ARE MORE THAN 400m IN THE DISTANCE
2. THINGS THAT ARE CLOSER THAN 8 cm
3. OBSCENE GESTURES
4. DUST OR SMALL HAIRS, MOST INSECTS, THE STARS AT NIGHT.
5. THE MOVEMENT OF THE HANDS ON A CLOCK, SNAILS, OTHER SLOW-MOVING THINGS
6. SUBTLE BODY LANGUAGE PARTICULARLY WINKS, NODS AND HALF-SMILES.
7. INCREMENTAL CHANGES SUCH AS ONSET OF PUBERTY, MENOPAUSE, DEMENTIA, FALLING IN LOVE, E.T.C.
8. THINGS THAT MOVE AT SPEED; CARS, BIRDS, SPIT, ETC.
9. DIFFERENCE BETWEEN THINGS ▬ THAT ARE SIMILAR
10. GLASS
11. WATER
12. SMALL TEXT

DEAR _____

THANK-YOU VERY MUCH FOR THE BASE-BALL
HAT YOU GAVE ME FOR MY BIRTHDAY. THANKS
ALSO FOR THE CRICKET BAT AND THE FOOTBALL
BOOTS AND THE BASKETBALL HOOP. THANK-YOU
FOR THE BOWLING BALLS AND THE DART BOARD
AND THE SNOOKER CUE. THANK-YOU FOR THE
SWEATBAND, THE CYCLING SHORTS, THE RUGBY
BALL, THE BADMINTON RACKET, THE DISCUS,
THE RUNNING SHOES, THE REFEREES' WHISTLE,
THE MOUNTAINEERING EQUIPMENT, THE STOP-
WATCH, THE AIR RIFLE, THE CLAY PIGEONS,
THE SWIMMING GOGGLES, THE JAVELIN,
THE PARACHUTE, THE WATER SKIS, THE
GOLF CLUBS. THE ICE SKATES, THE SPORTS
BAG, THE SQUASH COURT, THE RACEHORSE,
THE CUP FINAL TICKETS, THE SHUTTLE COCK
AND THE EASTER EGG. LAST WEEKEND
NIGEL AND I WENT TO THE CAVES AND HAD
TO BE RESCUED BY MEN ON A MECHANICAL
DIGGER. MUCH LOVE
_____ _____ XXXX

DEAR _____

YOURS SINCERELY,
